SONS OF GUNS™

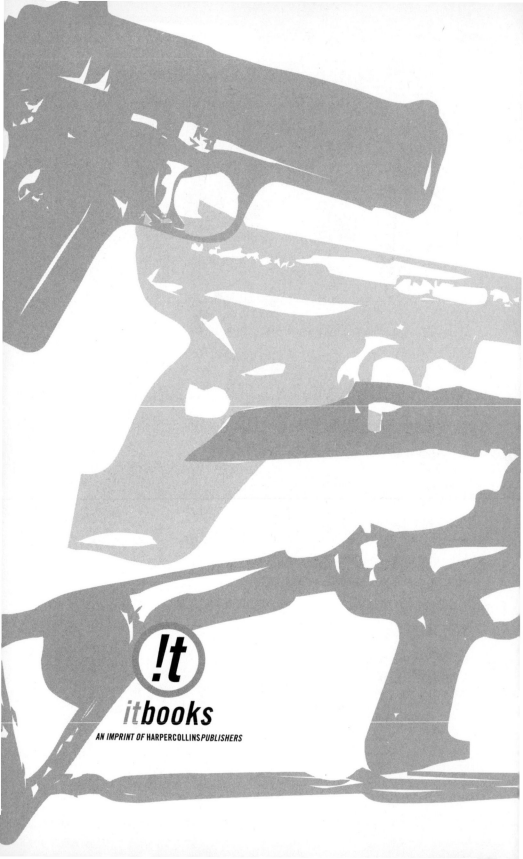

!t
itbooks
AN IMPRINT OF HARPERCOLLINS*PUBLISHERS*

SONS OF GUNS

STRAIGHT-SHOOTIN' STORIES FROM
THE STAR OF THE HIT DISCOVERY SERIES

Will Hayden

with Adam Rocke

HarperCollins books may be purchased for educational, business, or sales promotional use. For information please e-mail the Special Markets Department at SPsales@harpercollins.com.

FIRST EDITION

Designed by Paula Russell Szafranski

Library of Congress Cataloging-in-Publication Data has been applied for.

ISBN 978-0-06-227002-3

14 15 16 17 18 ov/RRD 10 9 8 7 6 5 4 3 2 1

To my wife, Rachel, and all
the years to come

SONS OF GUNS™

RULES FOR SAFE BOOK HANDLING

THIS BOOK IS LOADED.

DO NOT . . .

**Point it at anyone who
does not intend to read it.**

**Begin a chapter unless you
intend to finish it.**

**Start reading unless your
corrective lenses are in place.**

**Alter or modify its contents
without consulting Red Jacket Firearms.**

**Forget to tune in to
Sons of Guns on Discovery.**

Contents

Introduction

About five years ago, just for shits and giggles, I posted a video on YouTube. The video showed me—well, a sixty-pound-heavier version of me, thank you very much—looking like my usual pissed-off, semipsychotic self, wearing a wrinkled wife beater, cute-as-a-button bunny slippers, and my customary "I could give a fuck" grin, appearing as if I had just rolled out of bed, which I had (late night, woke up at the crack of noon, no complaints, it was fun as hell). I was smoking the stub of a cigarette and just flat-out cuttin' loose with one of our short-barreled Saiga-12 fully automatic shotguns. If you ever need a right proper remedy for the hair of the dog, trust me brother. A one-mag range session with a full-auto, short-barreled shotgun like our Saiga-12 is the prime ticket.

Now for those of you unfamiliar with this ferocious piece of hardware, it's the bees' knees. No joke. The kind

of weapon you see in crazy-ass action movies where shit blows up left and right and bullets fly like swarms of locusts on meth. It certainly ain't the typical "gun-store gun." Let's put it that way. Then again, Red Jacket damn sure ain't your typical gun store, but we'll get into that later.

So I rip through a full twelve-round mag in less time than it takes a fart to smell before turning to the camera, flashing the most sincere Colgate smile I can muster, and saying, "Red Jacket, motherfucker." Don't mean no thing—just my standard Baton Rouge "top of the morning to ya" greeting. That's just how we do it down here. And if you're offended by that, oh well. I ain't making no apologies.

Now videos are kinda like kids. You can raise 'em however you want, do anything you want to 'em in their rearing years, but once you turn 'em loose on the world that's all she wrote. It's outta your hands. Whatever happens happens. You can either go the route of the camel and bury your head in the sand and hope the storm passes you by or you can own up to it. Me, I own up to everything I do. No exceptions. I've said it before and I'll say it again: if you don't like me, or don't agree with how I do things, or don't subscribe to my ideologies, or don't like the cut of my shirts, that's on you. Go spit.

But what I *didn't* know at the time was Discovery had been looking to develop a reality television show to explore the very heart of the American gun culture by focusing on the daily antics of a small, mom-and-pop-type

gun biz—a retail shop that also had some sort of manu-facturing capability. This way they'd get insight into the industry, the merchandise, the design, and the construc-tion of the bang-and-boom devices we make, and, in our case, the nuts behind the counter.

Well I'm sure you can see where I'm going with this. The Hollywood folks saw my little video—rumor has it their eyes went as wide as saucers—and they immedi-ately gave the shop a ring, fingers fumbling because they couldn't dial fast enough. I remember the voice on the other end of the line like it was yesterday.

"Yes, good morning. We saw a video on YouTube and were wondering if the gentleman in it was still affiliated with your company?"

I had to stifle a laugh. I've been called a lot of things in my life—most of which I'd prefer not to repeat in case women or children are reading this—but I assure you a gentleman ain't one of 'em.

I took a drag on my cigarette, blew out a cloud of smoke, and casually replied in my customary "I could give a damn" Cajun drawl, "Yeah, I'm still here."

I could sense the excitement on the other end of the line—why, I have no clue—and the next thing I know I'm being confronted with another question.

"We'd like to send out a cameraman to your place, get some footage, and run it up the pole. See what happens. Are you okay with that?"

Cameraman? Footage? Run it up the pole? What the hell was this guy talkin' about? I know they have differ-

ent terminology in Hollyweird, a far cry from our verbiage down in Baton Rouge, but last I checked the folks in Californ-i-a still spoke English. At least a version of English. What this cat was saying, I hadn't the foggiest.

Still, what the hell was I gonna say? No? That would mean I actually gave a turkey's turd. If Discovery wanted to waste their time filming little ol' me and my boys doin' the stuff we do to earn our daily bread, more power to 'em. I mean I certainly didn't think anything they saw or filmed was gonna interest anyone, especially when it came to making a TV show. Cuttin' metal, drillin' metal, weldin' metal, paintin' metal, carvin' wood: the inner workings of a gun manufacturer—even with the cool-ass weapons we build and work on—didn't strike me as the kind of "entertainment" people would want to plop down on their couches and order in pizzas to watch. 'Course, it wouldn't be the first time I was wrong and it sure as shit won't be the last.

So you can imagine my surprise when a few months after that cameraman came and went, I got another call that the show had been "green-lighted"—Hollywoodspeak for "game on, you son of a bitch!" And the rest, as they say, is history.

Sons of Guns is now blessed with millions of viewers—they call 'em fans—and has been broadcast in more than two hundred countries.

Two hundred!

Really? How did that happen?

So I'm wondering . . . is it the guns we build and tin-

ker with? The lost souls who turn the wrenches, cut the metal, and actually expect a paycheck for their efforts each week? The folks throughout this great nation of ours who wanna buy our crazy products? Or is it because guns are and forever will be ingrained in the fabric of American society?

Hell if I know. And maybe I never will.

All I do know is that the Hollywood folks keep showin' up at my shop with their gear, stickin' video cameras and mics in the faces of me and my boys, recording all the stuff we love to do—along with some of the stuff we just *have* to do. If people out there wanna keep tunin' in, well, I'm flattered. Heck, I don't quite get it—seriously I don't—but I'm flattered nonetheless.

Red Jacket, motherfucker!

If someone has a gun and is trying to kill you, it would
be reasonable to shoot back with your own gun.
—THE DALAI LAMA

I'm Will Hayden, Damn Glad to Meet You

When I think of my background, my humble roots, I think of Creedence Clearwater Revival's "Fortunate Son." While the whole song applies, it's the chorus that really sums up exactly who and what I am: "It ain't me, it ain't me, I ain't no millionaire's son, no. It ain't me, it ain't me; I ain't no fortunate one, no." Then again, seeing as how some wordsmith musicians have already said it better than I ever could, maybe I should be quoting the entirety of Skynyrd's "Simple Man," 'cause

that's truly what I am. Nothing more, nothing less. Just a simple man.

To that effect, I live my life by a simple code. When I speak, you listen. When you speak, I'll listen. Imagine what this world would be like if people gave one another that simple courtesy. Not sure if we'll ever get there but, hey, stranger things have happened.

When you do speak to me, look me in the eyes. Don't disrespect me by lettin' your peepers dance around. Besides, I'm like a human bullshitometer; by looking you in the eyes when you speak I'll know if my chain's getting jerked. On the flip side of that sentiment, I ain't gonna be lookin' at your feet when I address you.

When I ask a question, I expect an answer. A truthful one at that. Don't tell me what I want to hear. Give me the straight dope. If I don't like the answer, we'll deal with that after. But don't try to avert an outcome, or a confrontation, simply by shining me on. That just wastes time. And time's something we're all in short supply of. Better to come clean and figure it out than circle the bowl waiting for the suck. John 8:32: The truth shall set you free.

Finally, when I give an order, I expect it to be followed. Sure, there's a time for play. But when we're working, that ain't the time. So if I'm telling you to do something, I don't want you to stand there and nod. I want you to disappear and get to it. Or better yet, know what I'm gonna tell you before I tell it to you and get to steppin' on your own accord. That's a surefire way for us to stay on the same knuckle-pounding page.

Of course, there's probably one more thing I should address—something fans of the show have come to know and appreciate. When I call for a Mad Minute, you damn well better stop what you're doing, grab every weapon you can carry, along with every ammo can, bandoleer, and loose round in sight, and beat feet to the predetermined rendezvous to take part in an epic display of full-auto mayhem.

Like I said, I'm simple.

Except now that I'm a "big TV star"—saying that makes me want to puke, it really does—people want to know my background.

Truth is there ain't all that much to know. I didn't grow up any different than a lot of other folks. Not around these parts, that's for sure. Understand, I ain't puttin' anyone down, just tellin' it like it is. And, like many people I know, I was the product of two rather uninspiring halves.

My mom's side is full of good-hearted people—*dirt-poor* good-hearted people. And I'm talkin' poor on a level most people today simply can't comprehend: no electricity, outhouse out back, century-ago poor. They had what they had, which damn sure wasn't much, and they learned to live without what they didn't. But they didn't think anything of it. It'd be like crying over rain if your house had no roof. It is what it is. Move on.

On my dad's side, other than a distant cousin or two, everyone was pretty convinced I was destined to be destitute. My dad was kind of a fuckup and they all figured I'd just carry on that tradition. The apple don't fall far

from the tree and all that. Hell, he put me through a wall with a punch when I was five. So, in the scheme of things, you'd think it would have to get better. I mean, age five, getting put through the wall with a punch, by your old man, no less; it's not like it could get much worse. But that incident taught me two very important lessons:

1. Don't mess with people who can beat your ass bloody on a whim.
2. If I can deal with being knocked through a wall by my dad at age five, I can deal with just about anything.

From that moment on I realized I had to pick my battles carefully. *Very* carefully. Any battle I could get up and walk away from was a victory. It didn't matter if me or my psyche looked or felt like it'd been run through a meat grinder. Victory is victory. However, the simple fact remains: you learn more from a loss than you do from a win.

Much more.

Think about it. You win, you get your hand raised, and then you immediately start looking around for your next battle, no doubt expecting more of the same. Hell, you won once, you'll probably win again. Just like piss precedes drunk, victory makes you cocky. And that's a real problem 'cause expectation and effort ain't often found in the same sentence. Take that day with my dad when I was five. What if I'd been older and bigger and the situation were reversed and I'd knocked *him* through a wall? What

would I have learned? It very well might have given me a false sense of machismo. Make me think I was tougher than I really was. And there's always someone tougher than you out there just waiting for the opportunity to prove it. It's the way of the world. That beating might very well have saved my life. Now, every day I'm here, every day I get to spend around people I love, that's my hand getting raised. That's my victory. It's not about your possessions, or getting things you want. It's just about being. And if more people could climb over to that side of the fence, I'd bet a case of Red Jacket AKs they'd feel much better about themselves, about their lives, about their legacies. They'd feel true fulfillment even if, financially or occupationally speaking, they hadn't achieved it yet.

Oh hell, what do I know? I'm just talking about my view of the world. I don't expect folks to Simon Sez to my philosophy, although as I've learned in recent years, being on television makes more than a few people think that's what I expect from 'em. Trust me. That isn't the case. I ain't preaching gospel, just living by my own agenda. What everyone else wants to do with their time on God's green earth, heck, go for it. Roll the dice and take your chances just like the rest of us. So long as your happenings don't interfere with my doings, we've got no issues. But beyond that, if you folks see fit to add this book to your possessions and my televised ramblings to your DVR schedule, well hell, how could I possibly complain about that?

But I digress.

Surviving my single-digit and preadolescent years wasn't the easiest cake to bake. Growing up in Dixie, just north of Baton Rouge, you had to be harder than coffin nails. Gunfights between twelve-year-olds weren't uncommon. Heck, they woulda happened earlier if kids back then had easier access to guns instead of rocks.

I didn't need to be a rocket scientist to know that guns beat rocks every time. But since I couldn't afford to buy my own bang stick, I made one. Found some discarded pieces of this and that at a construction site, including some rubber banding, a decent board, and a broken section of pipe that was as perfect as I could hope for considering it was just sticking out of the ground under a pile of debris. I cobbled it all together as best I could, drilled out a little center bolt to make it hollow, then filed away most of it until I was left with just one protrusion with a good, sharp rim intact (for rimfire) and voilà: my very own .22. 'Course, it was more like a zip gun than a real gun, but it was a gun nonetheless. Granted, it wasn't all that accurate—I could probably hit water if I fired it off the side of boat in the middle of a lake, *probably*—but that's just the cover-your-ass version of its capabilities. Like I said, I grew up in a rough neighborhood and I don't know what the statute of limitations is on any mayhem I may have been involved with, so let's just cap that thought and move on.

But what that "gun" could do was secondary to the fact that it was mine. And I was damn proud of it.

That homemade piece-of-shit pseudo-rifle got me

thinking bigger picture, about what I wanted to do with my life. Those days, in that area, there wasn't a whole lot to look up to. In order to aspire to be something, you needed to have something around that you would actually want to aspire to be. And I'm tellin' ya the pickings were more barren than an evil man's heart. To put it in proper perspective, those folks that managed to scrape up enough money each month to avoid being evicted from their hovels were livin' high on the hog. I didn't want any part of that. And I didn't want to go on to become some beet-nosed barfly talkin' trash about the hell I'd raised, the time I'd done, the prisons I'd survived. I felt I was destined for something bigger, even if most of those around me—my own family included—expected me to amount to nothing.

But how?

That's the thing about destiny. You can't make an omelet without breaking some eggs. And breaking eggs has never been a problem for me. Destiny more or less follows the same rule. I knew nothing was going to come my way unless I *made it* come my way.

Although I was far from a great student, I was an avid reader. If it had words, I'd bury my nose in it start to finish. I especially liked reading about history. The important dates. The important places. The important events. The important people. And of all those important dates, places, events, and people, the ones relating to battles and wars were the most interesting to me. I'd spend hours on end with that subject matter, taking it all in, compart-

mentalizing it for later use—even if I didn't know it at the time.

One of the stories that really got my juices flowing was about some marines. Now, I didn't know that much about the marine corps—there weren't any marines in my family—but everything I read about them was kinda the same. A group of these boys would be dropped out in the middle of nowhere with just the clothes on their backs and the weapons in their hands. Nothing else. No friends. No support. Nada. Yet whatever their mission was, no matter how hard—or even impossible—it seemed, those boys got it done. There's a sense of nobility and pride in that kind of dogged determination and un-flinching, unrelenting persistence.

It's like every one of them subscribed to a single mind-set: "fuck you, failure!" If that ain't inspiring, I don't know what is.

You read a few stories like that and it leaves an impres-sion. It'd leave an impression on full-grown, mind-already-made-up adults, so you can imagine the impression it left on me as an open-minded kid.

Age sixteen rolled around and I jumped in with the full ruck—literally. Dropped out of high school, passed my GED a couple days later, then enlisted in the Marine Corps Delayed Entry Program, where I'd go to boot camp after my seventeenth birthday.

My boot camp wasn't nearly as rough as some others had it. That's not to say we didn't PT enough to make an iceberg break a sweat. But when most folks think of

marine corps boot camp, San Diego ain't the city that comes to mind. But that's where I was—Marine Corps Recruit Depot, right there by the San Diego International Airport.

For the most part I kept my nose clean. I wanted to be a marine and I knew that any transgressions—uh, any *serious* transgressions—would keep me from that ultimate goal.

That's not to say I was an angel. Got a little too much of that horned, pitchfork-totin' troublemaker inside of me to make that claim. And on one occasion, that lil' devil nearly dug my ass a grave.

Remember what I said about there's always someone out there tougher than you? Well, I had just gotten done winning a fight against these two guys—don't remember the reason why we threw down but I do recall it was two on one, and I also recall they got the short end of that stick—when the brother of one of 'em awoke from a sound sleep, came out of the house, and beat me bloody.

"You quit?" he asked me.

Lying there, I was thinking to myself, Boy, if I could just breathe, I'd have enough air in me to utter the word "surrender."

Unfortunately, I was too busy choking to death, turning all sorts of colors, like a chameleon on a Twister board, and finally I just started flopping out. Thankfully, he saw the light going out of my eyes, got up off me, and gave me a couple kicks in the gut so I would suck in some air. I hoisted the white flag the moment I had the strength

to raise my arm and that was that. But besides that incident and a few other minor lapses in moral judgment, I graduated boot camp in 1982.

Aviation training in Memphis, Tennessee, was next and then I was off to New Orleans, not far from my original stompin' grounds, to work as a helicopter mechanic, fixing all the moving and/or noisy parts of Cobras and Hueys. But being a reservist sucked more than a nitro-powered Shop-Vac, so I switched over to active duty, which sent me to Camp Pendleton in Oceanside, California—a mortar round from where I did my boot.

I lost one rank by going active but my time in the service—including six months in Okinawa—was far more interesting. I finished up in 1987 with the rank of sergeant.

I did this and that for the next couple of years, always involving working with my hands. Although I'm a mechanic by trade, I'm a frustrated artist at heart. Building anything clears my soul. Take that piece-of-shit .22 zip gun for instance. It may have looked like hell in a hand basket but it began its "life" as garbage—nothing more than bits and pieces of stuff that had been discarded. I turned junk people threw away into something functional, which in most places in the world qualifies as a work of art. And if it doesn't, I couldn't care less. Beauty is in the eye of the beholder. That's how it should be. If more people were satisfied with their own accomplishments, their own successes, small as they may be, instead of always trying to impress the neighbors, damn what a world we'd have.

At some point along the way I got into the commercial refrigeration biz, hung out my own shingle—Red Jacket Refrigeration—and made a go of working for myself. I was married to a beautiful lady, we had three kids, and, as many of you know, having three kids opens more than a few cans of worms. Let me rephrase that. One kid can open a few cans of worms. Three kids are more like a worm-breeding farm. But it was a hell of a ride; Trudy and I were together about eight years or so and we had us some real fun.

In early 2002 I was renting a building from a man named Anthony "Scotty" Scardina. I cut my teeth under him in the refrig business; he taught me everything I needed to know and then some. On top of that, Mr. Scotty was gracious enough to help me get my own thing started. Can't say enough about that. But the building I was renting was much bigger than I really needed, so it made sense to convert the unused space into something to bring in more cash. Use every part of the chicken and all that. Just like in hunting, letting anything go to waste is a sacrilege.

Ever since that Frankenstein .22, I've enjoyed fiddlin' with guns. More than just fiddling around, I knew there were some world-class weapons I'd never be able to afford to buy, but if I could build 'em myself from parts kits—or build something—it wouldn't be just as good it'd be *better*. Thinking along those lines, the plan was to convert the front of that building into a retail gun store. Now, I didn't have much money to sink into it (try *none*) but I

knew that if I got some basic items, surplus stuff mostly, and added a selection of decent used guns, the looky-loos would come to browse and, hopefully, man up and buy. Besides being another source of revenue, it would give my wife's dad a place to hang out during the day and stop driving her mom crazy. The remoulade on that po' boy: it might even pay the rent on the damn place!

So that's exactly what we did. Trudy joined the mix, too, and she brought in a cousin who had been raised with her like a brother. Nice, neat little family gun/surplus store. He put in the floor, we hung some paneling on the walls, and I gave him some skin in the game. The deal was we'd all work it together.

I put everything I had into it. Anybody who knows me—I mean *really* knows me—will tell you without mincing of words that I'm not a half-assed guy. I may be a lot of things but half-assed ain't part of the description. All the way or no way. It's not just about the folksy saying "Go big or go home." It's about you. What you are, how you set yourself up to succeed—or fail. If you're not willing to really make a go of something—of *anything*—why bother taking it on in the first place? At least that's my view. I don't understand the alternative but to each his own.

So I sunk about forty grand in, literally everything I had, trusting in my instincts and my gut that I—that *we*—could make it work. There were a bunch of guns on credit, cash loans to build it all up, IOU notes pulling at me in all directions, but in my heart of hearts I felt good

about the decision and the plan we had in place.

And then we got robbed.

Anything that was worth taking—including the damn duffle bags to pack the stuff up and take it all in—got took. I was off doing a gun show when I got the call about the burglary. I raced back and Trudy was already there with her sons. Someone had just walked in like they owned the damn place and took friggin' everything. I'm shocked they didn't take all the little hardware bits holding the place together, to boot. And I'm not talkin' about some random walk-by smash-and-grab, either. This shit was plotted out. They used a big piece of cardboard from next door, held it up like a shield so they could walk past the camera and conceal their identity, and then just pulled the wires loose from the alarm box.

You're following me, right? They knew about the camera. They knew about the alarm. They knew which wires to pull. They knew how to bypass all the countermeasures we had. No matter how you slice it up, ain't no way it was a run-of-the-mill random-chance burglary.

Because guns were involved, the ATF (Bureau of Alcohol, Tobacco, Firearms and Explosives) had to get involved, and they showed up like flies on fresh shit. Of course, city cops were there, too. And just like my conclusion, one of their first inclinations based on all they saw was that it was an inside job. But that didn't exonerate me. If anything, it moved me to the top of the suspect list courtesy of the fact that many retail businesses get "self-burgled" for the insurance money.

'Course, I pretty much took myself out of he-done-it contention when I explained that there wasn't any insurance. I simply didn't have the money for a policy. Naturally, they checked that out and saw I was telling the truth. Nobody, not even the dumbest SOB on the planet, would rob his own biz without an insurance policy to cover the damage.

Now, the rest of this robbery story crosses deep into "dirty laundry" territory. We've all got dirty laundry. Nothing special or different about mine than anyone else's out there. But because I already give y'all a top-to-bottom view of my hamper on each and every episode, this particular dirty laundry I'll keep to myself. Let's just say my marriage didn't survive the aftermath. But while the familial demolition was devastating, I had more pressing issues on my hands.

For one, I had to fix the door. I couldn't just leave it open, granting free access to my refrigeration business to any Tom, Dick, or Harry who happened to wander by. That cost money I didn't have. On top of that, I had to deal with all the people who consigned items to the gun shop. I felt like I was responsible for their losses. Again, more money that was needed from an account that was already emptier than a bulimic's stomach. The rotten cherry on that melted sundae was my living situation. I didn't have one.

Busted marriage = homeless Will.

So I ended up living in the back of the store—a store with no front door and no inventory to sell in order to

make money to pay back all the folks I owed. Talk about a rock and a hard place: my woeful situation gave new meaning to the term.

Not that I needed to add any fuel to the flames that were rapidly consuming the trash heap that my life had become, but just prior to this all happening I had stopped doing any refrigeration work. And Mr. Scotty, the man who owned the property, had fronted me the money to build up a shooting range. The rent per square foot had also increased and we even did a five-year amortization so he could get his capital back. Add it all up and I was like a crippled fighter jet streaking toward an inevitable encounter with the ground. Only I didn't have a parachute to bail me out. Hell, I didn't even have a canopy to bail out of.

But wait; it gets worse.

The man with the most items on consignment—now the most *stolen* items—was dying of cancer. He was selling all his stuff to try to pay for his medicine. He had creditors piling in left and right and that just tore me up inside. I went above and beyond to make things right. Went to all my friends—even to people who weren't really friends—trying to scrape up as much as I could to keep it afloat. And people kicked in as best they could, but in the end nothing helped and it all just collapsed.

That led to the day when Mr. Scotty came in and seized everything. All the inventory, the fixtures— whatever was there. If there had been a stray cat livin' in the Dumpster he would have taken that, too. At that

point there was around six months of back rent owed, on top of his cash outlay for the range. All my creditors were screaming, wanting their pound of flesh. I couldn't buy inventory to sell. The range was essentially just an empty building, still in need of fixtures. Nothing was producing any income. I was a powerless, rudderless ship on an ocean filled with tidal waves and attack submarines— the torpedoes just kept coming.

So Mr. Scotty started his own company, Red Stick Firearms. For those not in the know, Baton Rouge is French for "red staff" or "red stick." He ran it out of there and made me an offer I couldn't refuse: I could keep living in the back, have a little cot in the office, and run it for him. Priority one was to get him all his money back and turn it into a self-sustaining business. If and when we got to that point, he'd allow me to buy him out of the inventory and start over. Start fresh. I agreed—didn't really have much choice—put my head down and barreled forward. It took quite a while—blood, sweat, tears, and more than a few years.

And while I was working for Mr. Scotty I built that first batch of AKs—twenty in all—for an Arizona distributor. He was looking for a kick-ass price and I was looking for some solid PR. So we struck a deal. He got a wholesale rate that would guarantee him a healthy profit and I got the mention I so desperately needed; the guns would be listed in his advertisements as "Proudly Manufactured by Red Jacket." That caught the attention of Atlantic Firearms, a major firearms and weaponry acces-

sory distributor in Bishopville, Maryland, and Red Jacket was off to the races.

Something I guess I should touch on before going any further is the process of becoming a licensed gun dealer. To get a Federal Firearms License, picture exposing yourself to a proctology exam—a proctology exam that lasts for months and involves a hell of a lot more than one person checking your pipes. That's kinda what it's like, only instead of using a finger, or a camera, the folks doing the exam use a goddamn electron microscope. I mean these people look at *everything*. But then again, they have to. You're gonna have a license to sell weaponry. And that's just for a basic FFL. Now, if you wanna deal in machine guns and suppressors, or take it a step further and start making your own arsenal of goodies, that's gonna require more time, more lookin' where the sun don't shine, and more money. And while I'm sure some people fall through the cracks here and there and the licensing body—the Bureau of Alcohol, Tobacco, Firearms and Explosives —misses some things they definitely shouldn't have, for the most part these folks know what they're doin' and do a damn fine job of screening.

Anyway, those first years using the standard procedure AK kits I was just trying to make 'em work properly. Trying to understand all the internals beyond the basics. Trying to get a feel for how to improve and refine something that was already brilliant by design. But beyond the hands-on training those kits gave me, my major thrust was to get everybody paid back as much as I possibly could.

The way it ended up, Mr. Scotty allowed me a couple hundred dollars every week. My salary was actually about three hundred dollars per week and two hundred of that would go directly to the debt. My first priority was the man stricken with cancer who had lost the most consigned items. That left me with about a hundred dollars for the week, which amounted to a couple cartons of cigarettes and a bowl of rice from the old Chinese place on the corner. Aside from that it was all work, no play. To hell with Will being a dull boy or however the saying went. And I couldn't afford to bring anybody else in there so I was an army of one. The store was open from 8:00 AM till 9:00 PM and then, once the range was up and running, I put in an additional three to four hours every day fixing it, cleaning it, improving it. Then I would get it all ready to do again the following day.

Wash, rinse, repeat.

Somewhere in there I started working regularly as a night security guard at a nearby apartment complex (Brandywine Apartments for those who know the area)—12:00 AM to 6:00 AM shifts, although sometimes I came on at 9:00, 10:00, or 11:00 PM—and that helped to pay the guy back even faster, as well as cutting in to some of the other loans hanging around my neck. I wasn't bailing on any of my responsibilities. The hole was dug. Even though I didn't dig it, it was dug under my watch. I was not only determined to climb out of it, but I was also hell-bent on filling it in after the fact. No friggin' way was I gonna fall in it again!

Funny thing, I was doing an interview not all that long ago and someone asked me about my sense of responsibility—where it came from and all that. The interviewer, I don't recall what publication or TV station he was with—there've been quite a few over the years—brought up billionaire Donald Trump. Trump jumped ship on hundreds of millions of dollars of corporate debt, screwing investors, leaving them holding the bag while he sailed off to greener pastures—something like that, his words not mine—and the interviewer was curious why I would willingly tear into my own lifestyle (it wasn't much of a lifestyle, trust me!) to pay the money back when I could have just as easily shrugged my shoulders, wiped the slate clean, and started over. Said it struck him like I was willfully swimming across a large lake with an anchor tied around my waist. He wanted to know where that sense of honor and integrity came from.

When he finished the question I just looked at him for a few moments. Hell, maybe it was longer than a few because I could sense he was getting impatient waiting for a response. But I honestly didn't understand the question in the first place. I mean, how do you *not* feel a sense of responsibility to people who entrusted you with something—money, products, whatever? It don't matter what the value is; it's the point that they trusted you with it in the first place. If you're not beholden to that concept then you've got a messed-up outlook. I don't subscribe to that train of thought. Those who do deserve a kick in the caboose and I'm being kind.

Anyway, I stayed with it. It wasn't easy but it was what it was. I even got robbed again, although this scenario had a much different ending.

When I was living in the back of the store, one night I woke up to the sounds of people trying to pry the door open. Apparently they were having some difficulty so they quit prying and decided to drive a damn car through the storefront instead.

As an added security measure I used to park my truck in front of the door at night. On top of that there were cement barriers with just a little gap in between. Damn if they didn't squeeze their car through the barriers, knock my truck out of the way, and ram the building. Next thing I knew some guy comes poking up through the debris with a stubby little MAC submachine gun. I grabbed the closest gun I could find and we traded a few rounds. There's more to the story, but without getting into specifics let's just say the bad guys ultimately found their way to the great beyond.

Some folks who heard the story but didn't know all the facts figured I was jazzed to the gills to get into a gunfight. They don't know shit. I just shot at the roof to make noise, trying to convince 'em to leave. I wasn't looking forward to the possibility of shooting anyone. Contrary to popular belief, there's nothing macho about gunfights. Shooting someone ain't pretty. It's not like you see in the movies and video games. Shooting someone is the nastiest thing in the world. I promise you that. It's blood—on

you, hot and sticky with the distinct smell of copper if you're in close. It's shit and piss. It's terror and horror and every other fear descriptor you can conjure up. Shooting someone is the worst thing you'll ever do in your life, regardless of the scenario that brought it about. Bodies don't fly across the room sparing you from seeing the end result. They get ripped apart, right there in front of you, those bullets doing what they're designed to do. And they do their jobs well. It's an image you'll never shake. You could Clorox your brain for a decade and it wouldn't matter. Ain't nothin' gonna erase that memory.

But I got past that, rebuilt the door and the wall, and went back to the working grind. Nothing was going to deter me from making it work this time. Not the economy, not the inventory or lack thereof, and certainly not some wanna-be robber SOBs. I was resin and the world around me was water.

Then my work force doubled when Stephanie turned eighteen and I brought her in to handle the books. After another year or so, saving every damn penny along the way, Mr. Scotty let us buy out the tools and parts and whatnot, and gave us a note for the rest—with a good faith down payment, of course. The note's term was a three-year thing where we'd be essentially working for nothing, but after that, if we made it, we'd be done. Out from under the thumb.

Steph was still working other jobs at the time—three if I recall correctly: admin work at an office, part-time wait-

ing tables and other duties at a restaurant, and working in a grocery store, too—and she initially fought against me bringing her into the mix full time. But by now y'all know me: I don't take no for an answer.

So we re-formed the company, and since Mr. Scotty was getting old, his daughter began managing all of his assets. Not sure if that was his wish or not but it happened regardless. Mr. Scotty's kids wanted him and his wife in a retirement home and they had the idea that the property we were renting was worth a fortune—where they got that idea I don't have a friggin' clue—so they wanted to sell it, split up the money, and be on easy street.

As you can imagine, renting under that situation was a steel bitch, so we put out feelers and finally got out of there. We set up on Florida Boulevard in a miniwarehouse with an office in the front. It was about sixteen feet wide, fifty feet in the shop, and that was it—less than half the size of the space we're in now. I put a foldout sofa bed in and lived there for about a year. I'd work in the back and Stephanie would come in during the day with her kids and do her thing with the books.

Then one day I was selling some guns to a guy and we got to talking. Turned out he had a building for rent, he named a good price, we struck a deal, and I moved us over to where we are now.

Operationally, nothing really changed. But because of the layout of the new place, I had an actual bedroom this time and genuinely felt like I was stepping up in the world. And by the time Discovery came along with their

producers and TV cameras, I had managed to transform the place into what a proper gun shop is "supposed" to look like.

For me, it wasn't about the look of the place—never was, never will be—but about the boys cutting the metal and turning the screws. Of course, my tribe gained a few members since those cameras first started rolling—we're a true melting pot of personalities and talents as I'm sure y'all know by now—making this company what it is today, much more than what it was when the producers first saw my YouTube video with the full-auto shotgun and the bunny slippers.

But I have to give the executive producer props. He told me right from the beginning that people were gonna tune in because of who I was. Because I was "real," which considering we're doing a reality show, seems like it'd be a good thing. And I'm glad people like what they see, but for the record I'm not "being me" to get ratings or get more business or anything like that. I simply don't know how to be anybody else. And it never occurred to me that I should try. I feel genuinely sorry for the folks who think they have to be something other than who they really are for any reason. I couldn't imagine living like that. Seems soulless. Unfulfilling.

And when you break it all down to its bare essentials, that, my friends, is the secret sauce about anyone coming to work at Red Jacket. If you've got the drive, the heart, and the stones to put in the hours and the sweat, it doesn't matter what your skill sets are or where your expertise

lies. Trust me. We'll put you to work. We'll find something for you to do. Red Jacket is for people who want to be a part of something bigger than just them. Now that's not me trying to get all rah-rah and pregame speech the gang, trying to fire 'em up and make it like we're building artificial hearts or doing brain transplants or anything of the sort. I'm just telling it like it is from the standpoint of a man who wants to be around people who want to be around each other. People who, at the end of the day—at the end of it all—know someone has their back, no matter what the situation. If people say nothing about us except that we work together as a family, warts and all, disagreements and all, stubbornness and all, hell, I'd take that to the bank every single day. Sure, I'd love to be accompanied by a hefty bag of cash to stick in the account, but that's in a perfect world and, last I checked, planet Earth was freakin' far from perfect!

But the ABCs of how I got here really just set the stage for the apparatus at the center of my world: guns. Big guns, small guns—if they discharge a round chances are I'm a fan. Now I hope that doesn't portray me as some sort of hillbilly gun nut 'cause that's definitely not the case. It's just that as an artist and a mechanic, I appreciate the straightforwardness and, for lack of a better word, the artistry that goes into the design of a *working* machine. And for firearms to be truly effective, they need to work every time you pull the trigger. Most do. Some do it much better than others.

With that in mind, and the very origin of guns

themselves—their invention and evolution—combined with my own pushing-an-elephant-up-a-staircase stubbornness about people being self-reliant, any time I think of guns, the image that always comes to mind first is that of a muzzle-loader.

While modern (and even futuristic) weaponry is what most people are talking about these days, not to mention what the world's militaries are wholly dependent on, mechanically speaking, even though I truly enjoy the challenges that come with creating and/or improving on these designs, I'd be lying through my teeth if I said they held the same place in my heart as muzzle-loaders.

The simplicity of the time when muzzle-loaders were first engineered and put to use will never be upon us again. Sure, everything is cyclical but with technology being what it is, those days are never coming back. I'm talking about an era when a man was a man and could do things for himself without having to call in the cavalry to help him. When people depended on their own skills, their own guts, their own initiative, their own resourcefulness to survive.

Either that or they didn't.

It's the Jeremiah Johnson view of the world. Not to go all Hollywood but, heck, I love good movies as much as the next guy so why not speak in those terms? That's why I like Harrison Ford. Not the characters he portrays but the approach he's taken to his work. He's always struck me as someone with integrity and dignity. When's the

last time you heard of him getting busted in the back seat of a car with a fourteen-year-old transvestite? It ain't never happened and I reckon it never will.

Not to go off on a tangent but the muzzle-loader side of Red Jacket is that chop-a-cord-of-wood-for-breakfast authenticity that I think most people in this country are missing in their lives. And if you delve a little deeper and weave that thought into the bloodline of American society, it doesn't hold well for our national character that we seem to have lost our sense of self-reliance. That's why it chafes my hide when I see our leaders up there propounding on the fact that we are to depend on them for our well-being and to put all our trust in one another because there will always be someone else to provide. That there

will always be someone else to help us. It's the hard work versus easy welfare approach. I'm just more for the actual reality on the ground: your ass is your own.

Every man on this earth is born alone and, for the most part, he's going to die alone, too. If you live your life under the fantasy that somebody's there to pick you up when you fall and wipe that little booger from your nose, oh my God, you are so screwed. If that's not the worst self-delusion I don't know what is. Yet it's become the common view and I think that's a tragedy.

Now, there's nothing wrong with doing all you can for those you love and taking care of your family and kids and all that. Nothing wrong with that approach at all just as long as they understand from the jump that you're going to do it and they know why you're going to do it. Otherwise, just handing them anything and everything on a silver platter, from the day they take their first breath till the day they take their last, is pretty much sealing their fate.

In terms of expectation, the most any of us can hope for—wish for even—is an opportunity to work hard. In that respect I have never given anyone anything. I think it's a poor favor when you do. Give 'em an opportunity instead. You know that saying: Give a man a fish and you feed him for a day. Teach a man to fish and you feed him for a lifetime.

I gave Stephanie a job. She could have very easily screwed it up. Same thing with the rest of my RJF tribe. I give 'em the job; the responsibility to perform is on them. Ditto for my youngest. I give her chores. I give her tasks

and she can do them well or not. And if she does them and does them well, she knows it, too. It instills a sense of pride. By the same token, if she does them poorly, I don't have to tell her. She'll know it. Hell, we all know when we don't do as good a job as we should. On anything we take on. Saying you don't, that's a cop-out.

People think I need to be at Red Jacket on a daily basis to mind the store. To keep cracking the whip, making sure everyone does as they're supposed to. Those folks should stop in to RJF sometime and take a gander behind the show's curtains. Crack a whip? Heck, I don't even have to *lift* a whip. My crew stays later than late, sometimes sleeping on the floor, just to meet a build deadline or to deliver on a promise to finish a design and reveal. Me being there or pushing them to work harder never even comes into play.

That's why some of the folks in the shop—hell, all of 'em now that I think about it—keep thinking I'm gonna come to 'em one day and tell 'em that I'm taking a few months (or a few years) off to go hole up in some cabin in the woods and carve on my guns and just be happy with the nothingness of it all. Sounds like a pretty cool idea, but life's all about timing and unfortunately my watch doesn't seem to have that mark on its dial at the moment.

Maybe some day but not now. Besides, if I ran off to be a gun-engraving, throwback-living hermit, I'd feel like a sellout hooking up a satellite dish to keep tabs on my favorite shows—*The Boondocks, Family Guy, King of the*

Hill—along with a few other comedies I watch whenever I get the chance.

Don't misunderstand the context of the previous statement. I could easily live without TV or the Internet or any of the other technological things the modern world has given us. But the one thing I couldn't live without is my family. Family keeps me grounded more than anything. And by family I'm not just talking about my immediate family. I'm talking about my Red Jacket family. These people aren't just employees, although sometimes on the show it comes across that way with me acting the order-barking fool, looking every bit like an overbearing boss man. No, these people are my blood, even if their DNA strands don't look anything like mine. I love 'em all for who they are, for what they are, and for what we do together. I know without question that each and every one of them could leave RJF and a heartbeat later have a better-paying job, with half as much stress, to boot.

But would they enjoy it as much?

Hell no.

Would they be able to rub elbows day in, day out with people they've come to admire, respect, and appreciate?

Hell no.

Heck, I'd even bet they'd miss the big bastard rants I occasionally go on.

Don't believe me? Ask 'em yourself.

They know where the door is. It ain't locked from the outside. They're free to go at any time. No contract binding them to me or RJF. Hell, I'd be the first one to write

'em a recommendation for a position somewhere else if they were so inclined or I'd help them any way I could if they opted to hang out their own shingle.

But of course I want them to stay. And stay they do. Heck, our numbers are growing like rabbits on Viagra. We must be doing something right.

We're like a big machine. Break it up and it's just a heap of parts. Sure, some of them parts are pretty snazzy and could easily be put to good use in another machine, even though that's not how they're best implemented. But put 'em all together how they're meant to be and that machine will just hum along. Yeah, it's gonna have some malfunctions here and there—maybe some that are serious, too—but that's the beauty about having a shop full of mechanics.

Ain't *nothing* we can't fix.

That's not to say I don't have an exit strategy in mind. Got me some acreage a way's off the beaten path but not so far that I'm totally off the grid. Just far enough that I can create my very own Fort Wilderness some day, the kind of place fathers and sons, mothers and daughters, family and friends can experience life like it used to be, when a hard day's work resulted in nothing more than the guarantee that you'd be able to do it all again the following day.

That piece of property is the same reason I stay active in the historic and reenactment community. To truly know where you're going, you need to know—need to remember—where you've been. And I'm not just talk-

ing about me. I'm not talking about us as a people. How we got here. Where we came from. The way life was long before the word "status symbol" became part of the average everyday conversation.

But the simple fact is I'm having way too much fun to "retire" just yet. I mean look at me. I'm the friggin' poster child for the American gun movement as seen from *both* sides of the aisle. All those in favor love me and want to shake my hand, buy me drinks, invite me to their BBQs, have me bar mitzvah their sons. All those opposed want to take potshots at me with the objects of their discontent. Who in their right mind would want to give all that up?

I didn't expect to get into this—well, maybe a little bit—but I suppose we should. First, it's imperative you understand that I understand the antigun folks' reasoning. I get where their anger stems from. Didn't say I agree with it, just that I understand it. Big difference. Problem

is they don't want to face facts. They want to scream and yell and stomp their feet and point the finger rather than deal with the problem head on and come up with a viable solution—or even a strategy that actually addresses the problem. Limiting the number of rounds any gun's magazine can hold is so far from addressing the problem it makes me wonder how these people advanced from the crawl to the walk phase in the first place. But the debate keeps the argument going—arguing for argument's sake—and keeps the people divided. It's much easier to keep fighting about a problem than to come together on a solution.

But I could go on and on about the political aspect of my job when, at the end of the day, I'm still just a guy who builds stuff—stuff that in the big picture I don't even like. And I'm not saying that to be self-loathing, either. It's just reality.

Every time I start building something I go into it thinking this will be my greatest creation yet. My masterpiece. I go in thinking I'm building it for me and me alone. Yet, midway through, I start seeing all the mistakes and begin hoping that I'll do a better job next time. Some people think I'm just being hard on myself while others think I'm nucking futs, but they don't see the imperfections like I do.

They see something amazing. I see something flawed.

They see something they can't wait to buy. I see something I can't wait to sell. Good thing, too, otherwise our retail biz would suck swamp water.

I'm not trying to be a perfectionist but every creator, no matter what level of "artistry" they bring to the table, is one—even if they don't admit it. You can't be a true artist without that mentality.

With the things I build I see where the architecture got a little hinky or a line went crooked or where I botched the flow or, hell, a whole host of maladies that just flipped the script on the original intent. So, no problem. Put a tag on it, sell the damn thing and move on to the next project. When it's gone, I never think about it again. After all, I didn't give birth to the damn thing. I just built it. Because again, bigger picture, it's not about the products. Cool as they are, it's not about what we build. It's about the people building them and the fact that what we're building—and getting to do it on television—is the means to an end, that end being the ability to take care of people. To give 'em jobs and let 'em unleash the artist that lurks inside every one of them. Contrary to popular belief, I have absolutely zero interest in or intent on arming the world. If you want a gun or already own one, good for you. Thumbs up. If you want something we make, hot damn, it lets me pay the notes on the buildings and keep the boys around. But that's where I draw the line. Putting a firearm in every hand or household isn't part of my political agenda, mostly because *I don't have a political agenda.* I have a political opinion and we'll leave it at that.

But I'd be lying if I said I wasn't having a grand ol' time. Twenty years ago, if you'd told me I'd be shaking hands

with King Abdullah II of Jordan and talking weapons and tactics with General Gary Harrell, director of KASOTC—the king's Special Operations Training Center—I'd have wondered aloud what the hell you were smoking. Then there's the chance to jump out of perfectly good airplanes (whoopee!), drive around in a built-up, beat-up, heavily weaponized Ford Bronco that's been monikered the War Wagon, and by and large just blow shit up on a weekly basis. If I'm not living every red-blooded American male's fantasy nearly every time I get out of bed—okay, I'm seriously stretching the truth now but I think you're gettin' where I'm coming from—then somebody better pinch me and wake my ass up.

I'm Will Hayden, Damn Glad to Meet You

I have a very strict gun control policy: if there's a gun
around, I want to be in control of it.
—CLINT EASTWOOD

The Origin of Red Jacket

If I had a dollar for every time someone asked me about the meaning of Red Jacket, I wouldn't have to sweat making payroll each week. Don't let my "big TV star" status fool ya: you ain't gonna see a Bentley or Lamborghini parked in front of Red Jacket anytime soon unless it belongs to one of our customers.

But I digress.

The first rule of Red Jacket: we don't talk about Red Jacket. The second rule of Red Jacket: *we don't talk about Red Jacket.* Now that we're clear.

Aw hell, I'm just funnin' with ya. I'm happy to set the record straight once and for all because it's a story I'm proud of. It's my history. My lineage. So I'll tell it to you exactly how it was told to me.

First off, I'm a mutt. Hell, show me someone who says they ain't and I'll bet all the sweet tea in Louisiana that if they climb high enough up their family tree, they'll find some branches they couldn't see from the ground, branches they never knew existed, branches that hold some funny-lookin' leaves.

Bottom line, we've all got a little mongrel in us. And it's a beautiful thing.

Part of my heritage is Choctaw Indian, among the original inhabitants of this great nation of ours—long before it even was a nation. My tribe hails from the region that is now four separate states: Alabama, Florida, Louisiana, and Mississippi. We are descendants of two different cultures—the Mississippian and the Hopewell—that lived all throughout the Mississippi River valley and its many tributaries. Nearly two millennia ago, the Hopewell created Nanih Waiya, a twenty-five-foot-tall earthen mound that is still considered sacred to this day. Historians have long theorized about the meaning of Choctaw, with the most logical answer being it's simply a derivative of Hacha hatak, the river people.

Sometime in the seventeenth century, the many Choctaw bands merged together before ultimately dividing into three main groups: southern, eastern, and western. That made things a little tricky for my ancestors, seeing

as the groups formed alliances with different European nations, which occasionally pitted the Choctaw against each other. The Choctaw on the Gulf Coast and in parts of Louisiana parlayed with the French. The Choctaw in the southeast aligned with the English. And during the colonial period, the Choctaw in Florida and Louisiana had a treaty with the Spanish. But during the American Revolution, most of my ancestors joined forces with the thirteen established colonies to help them fight for independence against British rule. Interestingly enough, before the great "Indian Removal," not a single member of my blood kin took up arms against the United States. Of course, it didn't work out too well for 'em in the end, but this is a cyclical world we live in. Who knows what'll happen a few thousand years from now. And my people are very patient.

Anyway, in the closing days of World War I, a group of eight Choctaws played a key role assisting American forces to emerge victorious in several major battles of the Meuse-Argonne Campaign (the final German push of WWI) as "code talkers." Their language was indecipherable by anyone outside the tribe, thus keeping their communications secret. In World War II, the United States Army once again relied on Choctaw code talkers to pass along information they needed to keep out of enemy hands.

In 1989, seventy years after the fact, the French government honored the Choctaw contribution to their WWI war effort by presenting the descendants of the original

code talkers with the Chevalier de l'Ordre National du Mérite—the Knight of the National Order of Merit.

However, the Choctaws began assisting American forces long before World War I. A century earlier, during the War of 1812, the Choctaw were instrumental in helping to defeat the British, using their unrivaled knowledge of the land as well as methods unfamiliar to organized military forces of the time.

During the Battle of New Orleans—the final major battle in the War of 1812—a group of my distant relatives joined forces with Major General Andrew Jackson in his assault against the invading British army; the English Crown was intent on seizing control of the enormous territory the United States had acquired from France roughly a decade prior via the Louisiana Purchase.

But unlike many of Old Hickory's soldiers who favored fighting in daylight, the Choctaw preferred a much different method. Using guerilla/special ops tactics hundreds of years before those words were introduced into our vocabulary, when the sun crept behind the horizon, my ancestors would paint their faces in our tribe's customary war colors—red for war, black for death, to hide their faces from God—and slink off into the darkness. Understand, they didn't just blend in with the night; they *became* the night.

They didn't need infrared goggles or circling AWACS with FLIR technology; they smelled their prey on the wind currents or detected their presence by the actions of the birds and animals. The Choctaw were the true and

rightful hunters of the land long before paler faces made their presence felt.

I often wonder if my blood relatives knew what was to come. They had powers of intuition that many would deem as sorcery. Surely they had to know that life as they knew it—as they had known it for thousands of years—was slowly being stripped away.

But that didn't matter right now.

The British represented the greater of two evils by a landslide margin and the Choctaw were more than up to the task.

Moving like panthers wearing sponge slippers over a velvet carpet they would sneak up on the posted sentries or even slip in among the British campsites and picket lines, their knives and tomahawks—handmade weapons passed down from generations prior, weapons that had spilled much blood including that of beasts who walked upright—sharpened to perfection.

Among these Choctaw was my great, great, great . . . I'm not exactly sure what the relationship was but he was pretty damn great. Let's leave it at that.

Just as it is with many hunters today, a kill just wasn't quite the same without a trophy. But unlike taking a game animal, where no part ever goes to waste following its death, killing a man didn't involve the same respect—especially a man who would kill you, your wife, or your child if given half the chance. And the British regimental soldiers were just such men. Therefore, a trophy from one of these invaders from afar would signify much more

than just the severe action it took to acquire it.

On this January night the air was cold, the earth frigid, and a foggy mist clung to the ground. In the dark, the British soldiers' red coats looked like muted lanterns, as if their flames were dwindling as the oil slowly burned away.

After spreading out and selecting their individual targets, the Choctaw made their move. Fast was slow, and slow was silent. The British soldiers never saw or heard them coming. They never even felt their attackers' ghostly presence until it was too late.

Quick, clean kills were the best. No muss, no fuss. No warning cry screamed out to the others. That way more soldiers would go to their graves every time an attack was carried out, creating a pallor of fear at every day's end when night descended.

Reaching from behind, a powerful, well-calloused hand would clamp tight over a British mouth. A quick twist of the head would expose the throat. And the rattlesnake-fast dragging of sharp steel across soft flesh would seal their fate. Warm blood would flow much like the great river that ran nearby and soon the spasms of dying would be replaced by the stillness of death.

But sometimes I think, if that were me, carrying the hopes and dreams of my ancestors every time I went on the hunt, knowing that my land—the land of my father, my grandfather, and his father before him—would soon be under the control of a "tribe" that didn't care for or respect it the way our people had since time immortal,

rather than make a fast kill, where even his soul wouldn't know the source behind its sudden freedom, I would spin the man around and look deep into his eyes, giving him a moment of true fear, letting him know exactly who had taken him from the mortal world.

But that's just my vengeance talking. In all probability my ancestors were far more courteous. Now back to the story.

After quietly lowering the dead soldier to the ground, my ancestor stripped the gaudy red coat from the cooling British corpse and, fresh bloodstains and all, shrugged it on. It was a cold night; beyond simply being a great trophy, the coat was protection against the elements and a luxurious one at that.

For years he wore that coat like it was a second skin, proudly displaying it for all to see. Not only was it a symbol of accomplishment, the ultimate belt notch for the enemy he vanquished, but it was also a symbol of extreme courage, for wearing it now, to be seen by any and all, was a sign of defiance toward the tyranny it represented.

As time wore on, so did the coat, eventually becoming little more than tatters. Perhaps the remaining threads were woven into a blanket, sash, or belt. Or perhaps the shredded garment was simply set ablaze one night in the family's hearth, a final ceremony forever memorializing the night it was earned. Whatever the case, the coat's presence would live on. For far beyond just being a trophy, a giver of warmth, and a topic of conversation, that vestment spawned a nickname.

Oshkhouma.

Red Jacket.

It was a moniker my ancestor bore with pride till the end of his days, for every time his name was spoken, all those around knew they were in the presence of a great warrior.

Years later, when I started looking into my lineage and began getting in touch with my heritage beyond just bucking up on my knowledge of the people I descended from, that story evoked a newfound sense of purpose. I'm not exactly sure how to describe it—sort of a meandering between religion and spirituality, delving deep into my own bloodline without letting it encompass me. It was just the right time for me to have a greater understanding and appreciation of who I was, where I came from, and my own pathway to manhood. So when I heard the story of Red Jacket, my chest immediately swelled with pride and my pulse quickened. I knew there would come a time when I would shoulder the burden—*the honor*—of continuing that proud lineage.

Many cultures believe that there's a time in every man's life when, if he's up to the task, he should take his own name. This is no simple matter. It's far more than mere pomp and circumstance. More than just personal (or familial) glorification. By taking a name, he must be resigned to defending it, no matter what may come his way. A line must be drawn in the sand, and if it's crossed retribution must follow. Your blood, and that of your an-

cestors, will come to a uniting boil, forever mixed, eternally fused, to guard that name.

When that time came for me, it wasn't so much a choice but an honor-bound duty. I took my ancestor's name. A name he earned. A name he was proud of. A name I will forever revere.

I am Red Jacket.

Blaming guns for killing people is like
blaming pencils for bad spelling.
—LARRY THE CABLE GUY

Guns 101

Ioften take it for granted that not everyone has a work-
ing knowledge of firearms. It surprises me that in
today's turbulent times those who didn't have the
benefit of a grandfather, father, uncle, big brother, or fam-
ily friend to take them shooting or hunting and impart
the finer points of gun safety and general gun knowl-
edge wouldn't take it upon themselves to seek out that
information—information that may just save their life
someday. With that in mind, for those who are enthusias-
tic about guns but, for whatever reason, don't know their
nose from their nuts about them, this chapter is for you.

Before we get into specifics, we need to talk basics. And when it comes to gun basics, the conversation *always* starts and ends with safety.

There's a reason I warn viewers at the beginning of every show about the dangers associated with firearms.

Firearms are friggin' dangerous.

If you can't comprehend that even the smallest weapon chambered in the puniest caliber can injure, maim, or kill you or someone else deader than Elvis, then you've got no business messin' around with guns. I don't give a rat's furry ass if you're an expert's expert and have shot every gun under the sun—BB guns to howitzers and everything in between. When dealing with firearms, weaponry, and explosives, even the smallest error in judgment or lapse of attention can piss on your parade big-time. So please, pretty please, with a hand grenade on top, be smart and be careful.

That said, here's eleven simple rules you should follow whenever guns are around. If you see anyone breaking these rules, leave the area immediately. Better yet, take the damn gun away from them!

———◆———

RULE #1 Treat all guns like they're loaded.

RULE #2 Never point a gun at anything you aren't willing to destroy.

RULE #3 If you ain't prepared to accept full responsibility for every round fired from your weapon, you damn well better have a good lawyer on retainer.

RULE #4 Don't load a gun until you're ready to use it. If you're storing it, it's got no business being loaded unless it's being kept for defensive/emergency purposes. And if that's the case, be damn certain no one else—especially kids—can get to it.

RULE #5 Keep your finger off the freakin' trigger until you're ready to fire.

RULE #6 Don't just know your target—know what the heck is *beyond* your target. If you miss (likely) or over-penetrate (likely), you're gonna find out the hard way.

RULE #7 Always use "eyes and ears" (eye and ear protection) when shooting a firearm no matter how loud or powerful it is.

RULE #8 If you aren't 100 percent certain about a specific weapon's condition or method of operation, leave it the f--k alone.

RULE #9 Always use the correct ammunition for the gun. If you like experimenting with loads but don't really know what you're

If you disagree with any of those rules, do me and everyone else a favor and load all your guns into the bed of a pickup truck, drive 'em over to the nearest range or sportsmen's club, and give 'em to someone who'll appreciate and handle them properly 'cause you sure as shit don't have a clue.

Okay, now that we've got the safety lecture out of the way, let's tackle a scenario that's all too common.

You've come across an unfamiliar gun and don't know if it's loaded or not. Here's how to make the determination without putting your eye up to the damn barrel:

STEP #1 Remove the ammunition-feeding device. If we're talkin' about an automatic (semi or full), remove the magazine. For a revolver, open the cylinder. For bolt actions, release the magazine plate. For other weapons, simply move on to the next step.

STEP #2 Clear the chamber. For automatics, open and lock back the slide. For bolt actions, open the bolt. For

doing, be prepared to kiss your fingers (and possibly other body parts) or your life good-bye.

RULE #10 Don't mix booze and/or drugs (prescription or otherwise) with your shooting sessions.

RULE #11 Don't ever try to clean a loaded gun.

———◆———

lever and pump-actions with tubular magazines, open the action and, if necessary, cycle (pump or crank) the action until the breech is empty, being careful not to put your finger on or near the trigger. For single-shots, over/unders, and side-by-sides, simply break open the action, usually with the aid of a button or small lever.

STEP #3 Visually inspect the chamber. You can also use your fingers to physically inspect the breech.

With the gun empty and safe, only a colossal mistake by you or an act of God will make it fire.

Up next are two questions I'm frequently asked: which is the best gun for self-defense and which is the best caliber for self-defense?

Personally, I think they're both stupid questions. Defensively speaking, you should use whatever gun chambered in whatever caliber you can shoot the best and feel the most comfortable with.

After that, if your life depends on it, you should use

whatever weapon is nearest you. I mean if I'm really in dire need of a gun, I'd much rather have a single-shot .22 in my hand than a double-barrel 12-gauge in the next room. It's not rocket science, folks, just common sense. But for those who wish to persist with the platform and knockdown power Q&A, here you go:

HANDGUNS

Chuck the cinematic scenarios out the window. What you see on TV and in the movies are best reserved for times when there's a script to follow. In real-life encounters, handguns are close-range weapons—nose-to-nose to ten yards tops. According to crime statistics, most armed encounters occur inside of seven feet. Beyond ten yards, even those with considerable training are more likely to plunk their neighbor or an innocent bystander than their intended target.

What's more, handguns as a general rule aren't the most efficient manslayers. Don't get me wrong. Pistols kill plenty of people on an annual basis, but once again, according to statistics, more than 80 percent of those shot with a handgun survive.

The reason?

First, not everyone shoots hand cannons like the .44 Magnum. To my knowledge, the only person I can recall lugging one of those behemoths around on a daily basis was Dirty Harry Callahan and, whaddya know, he had the benefit of a screenplay and the luxury of kicking back in a cozy trailer between takes.

Second, most shooters have piss-poor accuracy, especially under duress.

Third, medical technology for the treatment of gunshot wounds is quite good these days. Unless the wound is instantly fatal, chances are the victim is gonna survive.

Ready for a sobering law enforcement stat? According to police data, less than 10 percent of all rounds fired from department-issued handguns in officer-involved shootings actually strike their intended targets. Keep in mind that cops carry guns for a living, engage in ongoing training, and are required to pass qualification trials to demonstrate their proficiency. This isn't me knocking cops. This is me giving you the gospel on handgun combat. So when you remove the cop from the equation and insert the average civilian—yeesh! It's a scary thought and I'm being kind. For the reasons I just mentioned, many weaponry experts view their sidearm

||

as a means of shooting their way to their rifle or shotgun.

Choosing a handgun is an extremely personal matter, right up there with the selection of your spouse—perhaps even more so. Pick the wrong mate and you could wind up losing half your money and possessions. Pick the wrong gun and you could wind up losing *all* of your life. But at least with a gun, consistent practice will help you develop the necessary chemistry. Not sure I could say the same for you and your mate, although both types of practice sessions seem rather enjoyable! As for the types of handguns to choose from, they are:

Derringers (Single-Shot and Double-Barrel)

Backup guns at best, if you're thinking of using a derringer as your primary carry gun, might I suggest you contact your attorney immediately and get your affairs in order. Look, anything is better than nothing—better to have it and not need it than to need it and not have it—but relying on a weapon with an ultralow capacity, a small sight radius, and, for the majority of those on the market, a rather diminutive caliber, for anything other than a perfect one-shot kill you're probably just gonna piss your attacker off. Granted, you could always go the Blackbeard route. The legendary pirate was known for having many loaded pistols on him at all times. With derringers being as small as they are, you could probably conceal twenty or thirty on your person without too much effort. Good luck with that!

Revolvers

In this age of automatics, revolvers are the old standby. What they lack in capacity, they make up for in reliability. Unless the gun is a complete piece of shit, pull the trigger or, in the case of single-action, thumb back the hammer and pull the trigger, and it's going to go *bang* every time. Sure, automatics allow for a much faster reload but there are plenty of folks who, with practice, can dump stuff rounds (usually using a speed loader) almost as quick (if not quicker) than an autoshooter changing mags. But the biggest advantage to using a revolver is the sheer number of chamberings you can choose from, especially some of the more powerful cartridges like the .44 Magnum, .454 Casull, and the monstrous .500 S&W Magnum, which is capable of taking down just about anything on earth, Godzilla included.

Additionally, some revolver frames are so big and heavy

the guns can pull double-duty as meat tenderizers, war clubs, and boat anchors. But just remember, the bigger the round, the bigger the recoil (unless you brake or port the barrel). Follow-up shots tend to be difficult if the gun is a foot above your head—or if the barrel has smacked you in the face and broken your nose!

Just saying.

Semiautomatics

Aside from a few highly specialized pistols for military applications, most of today's mag-fed pistols are semiauto, offering high capacity and quick reloading, with ammo available virtually everywhere. By and large, quality is quite good across the board. But quality of the weapon won't trump your ability as a shooter. Practice makes perfect.

That brings us to the discussion of caliber—the size of the bullet a gun shoots—and what works best for self-

defense. The correct answer is: there is no correct answer. It's a debate that will rage for as long as people choose to weigh in on the subject—or until ray guns and light sabers replace firearms. Until then, here's a quick summary of what's out there:

A word to the wise: bigger doesn't mean better. This ain't the locker room where you're trying to impress the rest of the guys. Find a gun that fits your hand, allows you to shoot it comfortably and accurately, and that you can easily fieldstrip, clean, and reassemble after range sessions. Also, try to match the weapon to your specific environment and needs. If you're looking for a sidearm to wear in grizzly bear country, a 9mm will probably get you killed. Similarly, if you want a defensive handgun for urban scenarios, a .44 Magnum doesn't really answer the bell. Be smart, try a few (or many) before committing, and then practice every chance you get until that weapon is an extension of your hand.

COMMON PISTOL CALIBERS FOR
SELF-DEFENSE

‖‖‖

.22 A great plinking, practice and small game hunting round, it most definitely wouldn't be my choice for a "first grab" defensive firearm.

.25 Slightly larger in diameter than the .22 but, with its tortoise-like velocity and ho-hum energy, you'd almost be better off throwing the gun at your target rather than shooting it with a .25.

.32 Ian Fleming's British super agent's original weapon, the Walther PPK, was chambered in .32 ACP and rung up an impressive tally of bad guys. Of course, that was all in the realm of fiction. If my life were on the line, I'd move up the caliber ladder. Hayden. Will Hayden.

.380 AUTO A shortened version of the 9mm Parabellum, the .380 is extremely popular overseas where many civilians are prohibited from owning firearms chambered in the same caliber as police or military weapons. Far from the best caliber for self-defense, a well-placed round (or half a dozen of them) will get the job done.

9MM The most common handgun caliber around the world, the 9mm's pros—good muzzle velocity, reasonable muzzle energy, relatively low recoil, decent accuracy at short

ranges—trump its biggest con: not the best "one shot stopper." Because of the round's high speed, bullets tend to pass right through fleshy, upright-walking targets without delivering their full complement of energy.

.38 Hands down the most popular revolver cartridge, .38's can be devastating when used with hotter loads (+P) or frangible (pre-fragmented) ammo.

.357 MAGNUM
Basically a .38 on steroids, .357 Magnums generate cannon-esque speed and power but will also thump the shooter with recoil, a reason many spend their range sessions shooting .38 loads instead of full bore .357s.

.357 SIG
Developed by Swiss arms manufacturer SIG SAUER, the .357 SIG is an attempt to replicate the usually revolver-specific .357 Magnum ballistics in a semiauto cartridge. It's a heck of a man-stopper but gun choices are limited and ammo is scarce and, therefore, pricey.

.40 S&W
Jointly developed by two of America's premier arms manufacturers—Smith and Wesson and Winchester—the .40 S&W is seen as a compromise between the 9mm and the .45 ACP, offering higher capacity than guns chambered in .45 and better knockdown power than those chambered in 9mm. A success from the moment it was commercially available, many law enforcement agencies switched to the .40 S&W and there are those who believe the military will be making the switch, as well, in the near future.

10MM
Created by self-defense guru Jeff Cooper and originally adopted by the FBI for all their field agents, the 10mm has superior stopping power to the 9mm but also produces significantly greater recoil, especially from firearms with short barrels, thus making it less effective in the hands of most non-experts. Worth noting, the 10mm led to the development of the aforementioned .40 S&W.

.41 MAGNUM
Bridging the gap between .357 and .44, this hard-hitting revolver round never really caught on.

.44 MAGNUM
San Francisco super-cop Dirty Harry Callahan's caliber of choice, the .44

Magnum is capable of killing most big game animals in North America and was the guide's sidearm of choice until larger calibers like the .454 Casull and .500 S&W came about. As a defensive round, it's overkill and then some, although it still won't lift human targets off their feet as depicted in the movies.

.45 ACP

This cartridge began its life as a revolver round (.45 Long Colt) long before making its way into autopistols, most notably Browning's M1911. Like the 9mm it's extremely common around the world and the caliber of choice for many law enforcement agencies and military branches. Because of its relatively slow speed and heavy bullet weights, it is the ideal platform for subsonic ammunition in suppressed weapons.

.45 WINCHESTER MAGNUM

Based on the .45 ACP but with ballistics that equal (and often surpass) the .44 Magnum, very few guns are chambered in this caliber. But for those intent on hunting deer-sized game with an autopistol (check your local laws), this gun will do the job.

.454 CASULL

Developed back in 1957 by Jack Fullmer and Dick Casull, this cartridge once held the distinction of being the most powerful handgun cartridge in production. It's an absolute beast, ideal for hunting medium to big game. As a defensive weapon, unless you're being attacked by a bear or a car, I'd look elsewhere.

.50 AE

Israel Military Industries (IMI) was the first to chamber a handgun (Desert Eagle) in this enormous caliber. While these weapons are fun to show off at the range, the gargantuan size, near painful recoil, and serious overpenetration make them a poor choice for a defensive handgun.

.500 S&W MAGNUM

The reigning king of the commercial handgun cartridges, if you needed to select one pistol to hunt dinosaurs with, this would definitely be the one.

SHOTGUNS

The racking of a pump-action shotgun's slide is often more than enough to scare off a would-be robber before any further criminal action takes place. If, however, the miscreant doesn't flee and the shotgun wielder does fire, in the event the encounter is at close range, don't bother dialing 911. You'd be better off calling a maid service. Or skip the phone call and fetch your mop from the laundry room and get to work: you're gonna have a real mess on your hands. But for defensive encounters, distance needs to be taken into account. Inside twenty yards, loads like 00 buckshot can have the same effect as Thor's hammer—provided your assailant isn't wearing body armor. Then again, if you're dealing with intruders wearing body armor, chances are you're in a line of work where you don't need my advice on how to deal with them.

Now, if you've got a hostage scenario on your hands, whereby the bad guy has taken up a position behind someone you care about, unless your shotgun has a rifled barrel and is loaded with slugs I wouldn't attempt one of those action-movie-inspired "hostage rescue head shots." And even if my shotgun were all "slugged out," the risk of hitting the hostage using a weapon not designed for surgical shooting is just too great.

The biggest negative to using shotguns, be it for defensive or sporting purposes, is the recoil associated with them. A 12-gauge, even an automatic where some/most of the recoil is absorbed by the action, can still kick like a mule and not be the best choice for those among us of smaller stature. Of course, if the shit has hit the fan and you're defending your castle, chances are your adrenaline will be pegged and harsh recoil will be the least of your worries.

The other drawback commonly associated with shotguns is their inability to hold many rounds. Some of the modern tactical variants have extended mag tubes that hold eight or, in some cases, ten rounds, and then there are those—like our Saiga-12—that have removable magazines. A few newcomers to the market have dual tubes or rotating cylinders that hold anywhere from twelve to sixteen rounds. But of course you could always just go Rambo and don a few fifty-five-round bandoleers. Shoot, if that visual doesn't scare away anyone breaking into your home, you've got bigger problems.

Factor in the speed of target acquisition and the convenience of not having to aim precisely and you can see why, during the days of the Wild West, the man riding "shotgun" on a stagecoach was usually armed with a double-barrel shotgun, ready to convert would-be thieves into clouds of biological splatter.

RIFLES

Stepping outside pistol and shotgun range puts you squarely in the realm of the rifle. Whether you've got an SBR (short-barreled rifle) with a ten-inch barrel, a carbine with a sixteen-inch barrel, or a bolt action hunting rifle with a twenty-plus-inch barrel, hopefully you've had the prescience to match your weapon with the environment in which it will primarily be used.

For example, I wouldn't recommend using a bolt action .460 Weatherby Magnum to hunt squirrels; nor

would I climb into a tree stand with a tricked-out SBR pushing 5.56 NATO. And I certainly wouldn't want to go house-to-house in some urban combat hot zone with a lever action .30-30. That's not to say you couldn't engage in any of the aforementioned activities with the weapon I specified. It just wouldn't be ideal. That's the beauty of having a gun collection. Not only does it give you options when going shooting, but it also leaves less cash for your next of kin to fight over when you're pushing up daisies.

Assault Rifle vs. Battle Rifle

Civilian-legal, military-style weapons are all the rage these days. If it were up to the antigun community, these "black rifles" would be the first to get melted down. There are two distinct flavors: assault rifles and battle rifles.

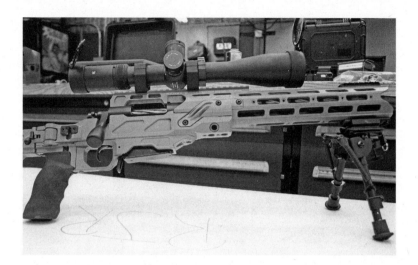

Assault Rifles

The origin of the assault rifle can be attributed to the most hated man in the history of the modern world: Adolf Hitler. His concept was simple: provide every foot soldier with a mini–machine gun perfectly suited for intense, short-range combat and as much ammunition as they could carry and let loose the dogs of war. What these weapons lacked in long-range effectiveness would be more than made up for in mass firepower. One counterintuitive benefit of the smaller and faster but ultimately less powerful rounds (.223-5.56) was their ability to kill at close range (inside one hundred yards) and seriously wound at longer ranges. But when you consider that a wounded soldier requires far more manpower to attend to than a dead one, strategically speaking, severely injuring your enemy was far better than instantly killing him. It's a brutal concept for sure

but in an arena where psychological combat is often more effective than actual physical combat, a concept routed in fact.

Battle Rifles

Unlike assault rifles, battle rifles are designed to kill at any range where small arms are employed. From point-blank to distances well beyond ideal clarity, the rounds these guns fire are heavier and more in line with those found in hunting rifles (.308, .30-06). As such, they can punch through hard cover without severely altering the trajectory. The downside: these rifles are typically larger and heavier than assault rifles, as is their ammunition, hence the magazines hold far less.

Sniper Rifles

Essentially hunting rifles for game that walks up-right, sniper rifles can take the form of heavy-barreled target or varmint rifles (.22-250, .243) for antipersonnel applications to big-bore blasters (.50 BMG) for hard-target interdiction, such as ground-ing aircraft on the runway. Almost always equipped with variable, high-power scopes, in the right hands these weapons will account for consistent hits out to one thousand yards and beyond. Bolt actions are inherently more accurate—fewer moving parts—but if expeditious follow-up shots are required, there are many semiautos well suited for sniper/counter-sniper applications. And while any cartridge could theoretically be used in a tactical scenario, there are currently five doing the lion's share of sniper duty around the world. They are:

.223-5.56 While most consider this chambering too light for tactical work due to its tendency to move off-line by even marginal wind gusts or small deflections, some law enforcement agencies are using it for close-range urban scenarios.

.308-7.62x51 Undoubtedly the most common sniper rifle chambering in the world, the .308 is used by virtually every SWAT team sniper in the United States, along with most of the elite police/military units abroad. Perfect for urban applications where tactical shots rarely exceed three hundred yards, the .308 allows for precision placement without going overboard in overpenetration.

.300 WINCHESTER MAGNUM While the .308 can be surgically precise in trained hands out to one thousand yards, some marksmen prefer the added punch and flatter trajectory of the .300 Win Mag. At longer distances, the .300 Winchester Magnum is the sledgehammer to the ball peen hammer of the .308. At closer distances, however, the .300 Win Mag will almost always overpenetrate, becoming a danger to anyone standing behind the intended target.

.338 LAPUA Designed as an alternative to the massive .50 BMG, the .338 Lapua has been referred to as the ultimate long-range antipersonnel round. Some even refer to it as the Quigley round in homage

to fictional nineteenth-century American marksman Matthew Quigley, who could hit any target at virtually any distance. With little to no wind deflection from all but gale-force winds, consistent one-shot kills out to two thousand yards are no problem for skilled shooters.

.50 BMG The big daddy of sniper rounds, the .50 BMG is an antiaircraft round that while effective on humans—anything it hits, it destroys—is best reserved for long-range hard-target interdiction (automobiles, airplanes on tarmac, artillery pieces, etc.). Brutal recoil (shooting without a muzzle brake is idiotic), concussive backblast, and prohibitive weight are the main detractors.

That leaves us with one final subject.

Ammunition

Just as you are what you eat, the same can be said of your weapons. Feed them junk and performance will suffer.

For practice, cheap ammo is fine provided it is well manufactured and doesn't chew up your gun's action or barrel. For life-and-death situations, buy the good stuff. You and your loved ones are worth it, no?

People ask me all the time how much ammo I should have on hand. Well, that depends. Are you among those expecting a zombie apocalypse? If so, chances are you don't have enough no matter how many rounds you've got stored in the basement or buried in your backyard. Beyond that, if you've got enough on hand to practice and still keep your weapon loaded to deal with an intruder, I'd say you've got plenty.

One final thought on self-defense and armed encounters, if only to give you something to think about: I'd much rather face a six-pack of heavily armed crackheads than go up against a SEAL or a ranger armed with only a bad attitude. Hopefully that makes sense. If it doesn't, well, let's just hope you never find yourself in either scenario.

Democracy is two wolves and a lamb voting on
what to have for lunch. Liberty is a well-armed
lamb contesting the outcome of the vote.
—BENJAMIN FRANKLIN

Sons of Guns
Best Moments

C hoosing a favorite episode or even just a favorite mo-
ment from a particular episode is like picking which
one of your kids you love the most. It just ain't some-
thing you can do.

Since this wild ride began there've been innumerable
incredible happenings—moments I will never forget for
as long as I continue to draw breath. However, there is one
project that really gets to me for all the right reasons—the

World War II flamethrower rebuild we did for Mr. Woody.

Now if you don't know who Hershel Woodrow "Woody" Williams is you really oughta slap yourself. Better yet, have a mob of people do it. For an hour or so! Then, when you're done gettin' knocked around, bone up on your American history. That's where you'll discover that Mr. Woody is a hero's hero, a man for whom courage should be measured in mountains because he is truly the Mount Everest of bravery. He's also one of the most incredible men I've ever met, show or otherwise.

During the Battle of Iwo Jima, this badass marine—a corporal at the time—working all by his lonesome and covered by only four riflemen, used his assigned weapon, a flamethrower, to clear enemy machine gun bunkers—commonly referred to as nests—from the route American tanks were hoping to open to pave the way for our infantry.

He could hear bullets repeatedly bouncing off the flamethrower's liquid fuel tank, any one of which could have instantly turned him into a human inferno, yet on he went, racing back to his own lines numerous times to exchange his empty weapon for a serviced or refueled one. This frenzied action continued for more than four hours, the preface to the famed raising of the stars and stripes later that day atop Mount Suribachi.

It's hard to say just how many American lives his actions saved. Dozens? Hundreds? Thousands? But the number really isn't important. Just the fact that he willingly put his own life on the line, literally becoming a

moving target—a rather slow one at that considering the heft and bulk of his weapon—in an effort to protect the men he served with goes well beyond any numerical statistics historians could conjure up.

The higher-ups clearly agreed with that assessment and President Truman presented him with the Medal of Honor, the United States of America's highest military honor, for his acts of courage and valor "above and beyond the call of duty."

When I met Mr. Woody at a war museum and learned he was looking to have his old flamethrower restored, my chest filled with pride at the chance to serve a man who had served every American so well. But there was also some hesitancy on my part. You see most sane people have a healthy respect for fire. For me that healthy respect traipses well over the line into the depths of fear. Fire scares the daylights out of me, stemming from my earliest memory as a child when my father pulled me out of a burning house. I have that nightmare at least once a month and can still smell that home burning down around me. But I figured that if Mr. Woody could blot out the fear that had to be raging inside him when he stormed those machine gun nests over and over and over—looking death square in the eyes every single time he faced them down—then I could keep my feelings under wraps and help this great man rekindle the relationship with his old flame, pun intended.

Whenever you rebuild any vintage weapon there's always a chance something will go wrong—usually at the

worst possible moment, too. There doesn't have to be any warning, either. One moment the weapon is singing away, making the prettiest sound you ever did hear, and the next it's coming apart in your hands. With the weapon in this case being something as volatile as a flamethrower, which is an ornery and unpredictable bastard on its best days, even a minor malfunction would undoubtedly result in a world of extreme hurt—and that's putting it mildly.

Still, we wanted to make this particular client presentation more than just the typical run-of-the-mill show and shoot. We did the whole package for Mr. Woody, right down to the little pillbox area the machine gunners were ensconced in, just like he was back in the day. We set it up at a state park in the lake-beach area where he could sit and relax and get shade to escape from the "hostile environment" we were re-creating at a moment's notice just to be sure that in the heat of the demonstration his subconscious mind knew it was all just a fake scenario.

I couldn't believe my eyes when this eighty-seven-year-old man popped that seventy-pound flamethrower on his back like it was just a backpack of school books and absolutely let loose, rolling the flame like he was still twenty-one and in his prime. Kris went running over there trying to help him and Mr. Woody just shrugged him off—"I got it, I got it"—and kept the flamethrower spewing fire, his face lit up just as much as his targets, if not more.

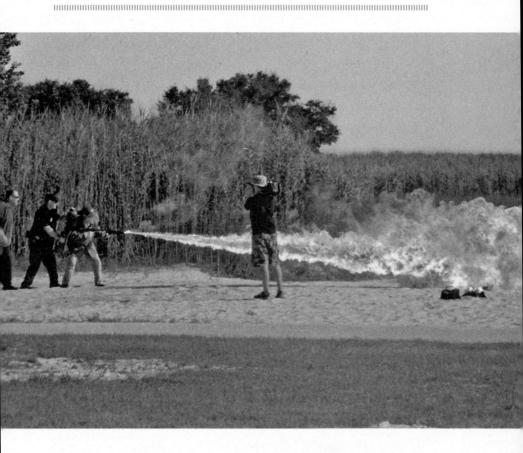

He spent about a week with us and shared many sto-
ries about his adventures, from that day on the beach to
his subsequent wounding later on in that five-week-long
battle (for which he was awarded the Purple Heart) to
his eventual retirement in 1969, after seventeen years of
dedicated service. Being in his company, just a couple of
jarheads talking shop, I probably got just as big a thrill
that week as he did.

Another build I thoroughly enjoyed took place on the

episode titled "Will's Floating Fortress." The customer was someone I admire and respect, East Baton Rouge sheriff Sid Gautreaux. We created mounts for the M240 Bravo machine gun and the Mk 19 grenade launcher to be used on the sheriff's Gulf patrol boat, which he uses for both drug interdiction and homeland security ops. He's got a tough job and covers a large section of the Mississippi River, so this build had to be spot-on.

But for the record, whether we're working on a pissant .22 or a 90mm cannon, if it leaves the shop you bet your ass it's built to perfection. When it comes to our guns, we don't skimp at Red Jacket.

Testing that GPB gear was beyond cool. We had five or six boats in a V formation, making wake, with a helo buzzing overhead, and riding back at night—with the spray lookin' eerie as hell in our NVDs, kinda like liquid pearls—it felt like a scene right out of *Apocalypse Now*.

Meeting Max Brooks, Mel's son, author of *The Zombie Survival Guide* and *World War Z*, was seriously cool, not because I get a thrill out of meeting celebrities or anything like that but because we were able to showcase a product I'm quite proud of, the ZK-22 Ruger 10/22 drop-in stock kit, which Mojo (Joe Meaux) had dreamed up nearly six years prior. It's one of RJF's best sellers and a damn fine weapon system for slaying the walking dead.

Another fun shits and giggles moment was showcased in the "Anniversary Bash" episode. I had the M2 locked and loaded on the back of my Bronco War Wagon and for the finale I was gonna lay waste to this target that Mojo

had amped up with about twenty pounds of "boom st

I noticed that it was getting toward the end of belt—high time to take the target out. Out of habit I h the gun rested on the target—a two-inch square of bla tape on a wall—roughly 150 yards away. Now there w some interesting math that I had to deal with because th target was actually inside the structure, about two feet o so back, which meant I had to pull the handle end at just the right angle, calculate the drop, mentally gauge the deflection angles, all of that. So I'm just sitting there focusing on my front site when they called, "Fire!" A nanosecond later I gave the butterfly a little goose and *bang!* Cored it. The explosion was awesome. Sent shit flying for fourteen acres. Talk about one shot, one kill. Problem is I don't think everyone was expecting that kind of immediacy but, hey, we got the shot.

More recently, the PKM we built for "One Man Army" was an extremely satisfying project. It was a build that I can see having a definite place in today's military.

As it stands, the PKM is a nasty weapon, but since it requires two or three people to operate it properly that makes it rather cumbersome. And ask anyone who's been in combat, cumbersome ain't what you want when you've got people shootin' back at you. But the job we did on it—shortening the barrel and the gas system, along with mating it to a backpack feed system—makes it perfectly man portable, which Mojo demonstrated to the nines.

But if I had to pick one consensus moment when everyone in the shop got an absolute thrill, it would have to be

when Chris Kyle paid us a visit. First and foremost, Chris is the epitome of a warrior. He's a former Navy SEAL who did his job time and time again, under the most arduous of circumstances, and never came up short. During his four tours of duty, Chris was shot twice and tagged in six different IED explosions, but like the soldier version of the Energizer Bunny he kept going and going.

The author of the *New York Times* best seller *American Sniper*, Chris is the most lethal sniper in American history with 160 confirmed kills (out of 255 claimed). He became so proficient at his craft that Iraqi insurgents nicknamed him Shaitan Al-Ramadi (the Devil of Ramadi) and put a price on his head, a bounty that eventually skyrocketed to eighty thousand US dollars—a mind-bogglingly massive sum to the average Iraqi. Chris was also part of Operation Neptune Spear, the code name for the raid in Pakistan where Osama bin Laden was killed. Some say Chris is the one who pulled the trigger; those who know the truth aren't talking.

Chris paid Red Jacket a visit for a custom buildup of a Heckler and Koch 416—the gun that killed bin Laden—which was to be auctioned off at a charity event benefiting FITCO Cares Foundation, the nonprofit organization that created the Heroes Project, providing free fitness equipment, personal training, and life coaching to veterans with disabilities, Gold Star families (families who lost a soldier serving his/her country in battle), and soldiers suffering from PTSD.

In addition to modifying the hell out of the weapon to Chris's exacting specs—shortening the barrel and stock, removing all creep from the trigger, installing a forward grip and various optical devices, and making it "mission ready," capable of functioning flawlessly no matter what it came in contact with (water, dirt, sand, etc.)—we also set up a course for Chris. This was Red Jacket's take on the bin Laden compound to properly demo the weapon.

In typical Chris Kyle fashion—the guy is an action hero in the truest sense of the term—he speed roped out of a helo, ran the course roadrunner quick smoking every tango we set up, and wasn't even breathing hard when he finished.

Tragically, not long after his time with us, Chris was shot and killed at a gun range by a fellow veteran—a young marine suffering from PTSD who Chris was trying to assist.

Like everyone who had the pleasure of meeting Chris Kyle, I will certainly remember and cherish our time together. The man will surely be missed.

The end move in politics is always to pick up a gun.
—R. BUCKMINSTER FULLER

Sons of Guns Fiascos and Failures

The shit didn't just hit the fan; it absolutely obliterated it! But those who have come to know us from *Sons of Guns* or through direct dealings with Red Jacket wouldn't expect any less. After all, the exotic destructive devices we tinker with on a daily basis are serious pieces of hardware, not the run-of-the-mill stuff you tend to see at your local gun club's Friday night turkey shoot. So when one of our "crazy as a soup sandwich" scenarios turns

FUBAR, trust me, you'd be wise to duck and cover.

Or better yet, *run!*

Fast.

And far.

When it comes to testing hard-core weaponry, especially weaponry you've manufactured from scratch or modified well beyond the original specs, it helps to have a grand plan in place, a plan you've worked out from A to Z and everything in between, addressing every possible scenario you could expect to encounter. And if you've done your homework, dotted all your *i*'s, crossed all your *t*'s, it should look right as rain on paper. Picture friggin' perfect. But just like a fight, that grand plan goes to hell in a hand basket the moment you get decked in the face.

And that's exactly what happened in this situation—two-by-four to the kisser proportions—except my face was the least of my worries. My boys, the camera crew, anyone who happened to be within a few city blocks: that's where my attention was focused. Technically, we were all in the crosshairs, on the verge of rubbin' elbows with angels—or demons (as Billy Joel says, we'd all "rather laugh with the sinners than cry with the saints"). Now if that sounds like a big bowl of stink on steroids, that's because it was. And then some. But hey, don't take my word for it. Judge for yourself.

Mess with the bull enough and sooner or later you get the horns. I wish that weren't the case but God didn't bother consulting me when he made the rules. On this

particular occasion, which was immortalized in the episode "Grenade Launcher Silencer," we took playing the matador to a whole new level.

Red Jacket had been commissioned by a pioneering Alabama gun manufacturer to help take his new version of a proven weapon system from the blueprint stage to living color. The weapon he was fiddling with? None other than the Mark 19 grenade launcher.

Now let me just start by saying the Mk 19 is a true bitch's bastard and, up till then, was the wickedest, most destructive weapon we had ever laid our hands on. Introduced into service in 1968 during the Vietnam War and still seeing frequent use today in hot zones around the world, the Mk 19 is belt-fed and fully automatic, firing 40mm projectiles at a rate of ten rounds per second out to a maximum range of more than two thousand meters. Rounds are multimission capable; they can deliver a wide variety of payloads: smoke, flare, buckshot, thermobaric (fuel-air bomb), high explosive (HE), and even nonlethal variants like CS tear gas and foam pellets, perfect for crowd control. Of the many different munitions, HE rounds are the ones most commonly associated with the Mk 19 because of their awesome destructive power. Not only do they deliver one hell of a wallop, but they can also punch through two inches of armor plating such as you'd find on IFVs (infantry fighting vehicles) and APCs (armored personnel carriers).

But what really makes the Mk 19 the belle of the ball is that it's man portable. Granted, you had better eat your

Wheaties if you plan on totin' that sucker around—it weighs seventy-two pounds without the tripod—but for urban combat scenarios, when you have a hankering to reduce a building to rubble and there ain't any air support to assist, the Mk 19 is your huckleberry.

Clearly a military weapon, the goal of this particular build was to give the Mk 19 more of a civilian application, something police departments could rely on in dicey situations. That meant converting it to select fire; semiauto would greatly improve its accuracy—pinpoint, baby—and, to keep it from blowing out the eardrums of anyone in the vicinity, quieting the little monster down to turn your head and cough decibels. Thus, the pièce de résistance would be a suppressor, something that had never even been considered for a grenade launcher. My boys and I were just foolish enough to give it a go.

Amazingly, after considerable trial and an even greater amount of error, using our custom-made components combined with those from an antiquated parts kit more than forty years old, we did the impossible—or what most people said would be impossible; at Red Jacket, "impossible" isn't a word in our vocabulary. There ain't nothin' we can't build!

Now that the reconfigured Mk 19 was assembled and ready to go, all that remained was to cycle some rounds through it and prove it could do everything it was designed and built for.

That's where this story takes a nasty detour.

Fans of the show know we take our test sessions seri-

ously. Paper targets just don't cut it, especially for something as badass as a grenade launcher. Hard targets are the ticket. So we brought in a junked-out SUV and also built a shack that we designated the "crack house."

While the Mk 19's ordinance will create fireworks aplenty all by their lonesome, we live in a world where bigger is always better so we rigged the shack with fifty pounds of high explosives. When the 40mm round connected there'd be a mind-numbing boom immediately followed by the early stages of the apocalypse—fire, smoke, and debris as far as the eyes could see.

It was a great way to end an episode, or so I thought. Good thing I don't get paid to think. I'd be even more broke than I am now and that's really saying something.

So when the time came for the big finish, we took dead aim and stroked the trigger. The grenade launcher bucked, the 40mm round flew straight and true, and—nothing.

No *boom*. No fire. No smoke. No debris.

Nada.

Shit.

I felt like the world had come to a screeching halt and God himself was pissing on my head.

Someone had to fix this mess. If for no other reason, by law you couldn't just leave a serious chunk of explosives just sitting out in the open.

Bizarre, huh? Go figure.

Next thing I know I had grabbed the items I thought I'd need and was about to beat feet for the shack when a

heated discussion flared up—peanut gallery opinions as to what exactly was required to remedy the situation, along with more than a few volunteers to do the deed. However, I didn't want to hear gums flapping. The only noise I was interested in was the sound of their shoes making tracks in the opposite direction. So I immediately cut the hero crap short by barking at everyone to get their asses out of Dodge. There are times when being an intimidating SOB has its advantages and that was surely one of 'em. Nobody saw fit to question me. They just heeded my words and skedaddled.

When I got to the shack it was just a big ol' freakin' yard sale of a mess, and more than a little hard to see courtesy of the dust that got kicked up and was still swirling. But after a few moments the air settled enough so that I could see what the problem was. It wasn't pretty. The round had skipped like a flat stone across a still pond and bounced up into the rafters, tearing through the two-pound picture light charge in the process. It must've missed the mark by an ant's pecker because a big wad of detonator cord was torn loose and the detonator itself was just dangling. That's when it occurred to me about all the static electricity I had built up walking over. Between the diesel fuel, the gasoline, the explosives, and the open flame it was like holding a dragon by the balls.

A *big* dragon.

A big, *fire-breathing* dragon.

And my hand was getting tired.

Long ago I got comfortable with the idea of dying. Not

saying it was something I was looking forward to, just an inevitable scenario I had made peace with. Like death and taxes. And just as it is with the government, sooner or later the Grim Reaper's gonna get what he's owed.

But that sentiment also applies to life. Some things just need to get done. And somebody's got to get 'em done. You ain't gonna send your kids, or your employees, or some hapless idiot to do your bidding. You just gotta nut up and do it yourself. Well, this was one of those times. I didn't need anyone to remind me of that fact, either. But it's in situations like these when I hope Zen and good karma count for something. Where some cryptic little voice will say, "Hey, you look out for the people you work with, so we're gonna look out for you on this one." Of course I don't know how many "this one's on the house" situations I've got saved up in the bank—if I've got any—but a man can hope.

Then again, it may just be that Jesus gets a kick out of me. Fools and drunks and all that yin yang. He's like, "Are you still walking on my earth, you big, dumb son of a bitch? Well, we're gonna keep you around a little while longer 'cause you're the entertainment. Damn fine entertainment at that."

That day I played the jester for sure. But I was able to walk away with all my parts intact, no one got hurt, and, holy Hollywood, we got the shot. If that ain't a great way to end the day, I don't know what is.

Unfortunately, that wasn't the only mishap we've had since the cameras have started rolling.

In the episode aptly named "Flamethrower Cannon," Red Jacket was tasked with completing the buildup of an industrial-size flamethrower—a massive weapon more along the lines of a flame cannon. The maniacal device featured two barrels, one fueled by a gasoline/diesel mix, the other barrel spewing napalm. There are more than a few issues to consider when building any weapon that utilizes flame, especially one of this size, but the biggest concern is the heat. Without a proper heat shield, not only is the weapon's operator susceptible to inadvertently getting cooked, but also so are the two tanks containing the fuel mixtures, in this case big suckers holding one hundred gallons apiece. If either of those puppies combust, the likely result is a human barbecue that even the most diehard cannibal will take a pass on.

On top of the potential problems that go hand in hand with building a flame weapon, I had my own flame-specific issues to deal with. I've said it before and I'll say it again: I despise fire. Actually, I don't just despise it; I *hate it*. Fire scares the you know what outta me. As to harnessing fire in a monstrosity of a contained weapon system, hell, I'd rather perform a tonsillectomy on a Tyrannosaurus—while the ferocious dino was awake! But our motto is: "If you can dream it, we can build it," and since this particular customer, a longtime friend of RJF, had this flame cannon dream of his since 1962 when he was just eight years old, I decided to shelve my fears like I had done with the flamethrower rebuild for Mr. Woody, put on my big boy pants, and man up.

Red Jacket did its part, creating a functional heat shield along with a beefy mount stout enough to handle the flame cannon's weight. And the test fire started off just fine with the flame cannon—quite possibly the biggest in the world—spitting out a tongue of fire akin to one a medieval dragon might produce. But it didn't take long for the demo to turn from "all systems optimal" to "run for the hills" when highly flammable liquid started leaking out and the automatic pressure relief pop-off valve Jiffy Popped before we could manually shut the cannon down.

You've undoubtedly heard the expression "Don't play with fire because you might get burned." Well, standing just inches away from a couple hundred gallons of weapons-grade fuel with an out-of-control flame cannon spewing dragon's breath, getting burned was the least of my worries. My mind was wandering into the realm of spontaneous explosion. However, we managed to shut the monster down before the devil opened a second Hades in Baton Rouge.

After the leaky valve was repaired we got the flame cannon back on track and laid waste to a rusty old car, a dilapidated Katrina trailer, a boat that was already well on its way to Davy Jones's locker, and, to appease Kris, some hot dogs for the ultimate weenie roast. All in all I loved it but that didn't mean I liked it if you get my drift.

Then there was "The Meat Chopper," when we took two MG 42 dual antiaircraft mounts and fabbed them into a single quad mount complete with a fire-control system that allowed us to fire all the guns at once, effectively

cranking out forty-eight hundred rounds per minute. The idea was inspired by the halftrack-mounted Quad-50 M2 .50 caliber, a highly effective antiaircraft weapon from World War II.

Our creation used four brand-spankin'-new scratch-built guns and looked about as wicked as the Grim Reaper without makeup or a good night's sleep. As to its functionality, well, that left a wee bit to be desired.

After a few moments of intense fire, all four weapons seized up and stopped working. Flem noticed that one of the guns was jammed and tried to clear it manually. Bad idea. The bolt slipped, snapped forward, and nearly took his finger off in the process. We tore into it and thought we got everything sorted out, but when the client gave it a go only one round was discharged before the whole thing locked up again. Still, we ended up puttin' a smile on the client's face, giving him some serious full-auto fun time with two of the four guns blazing away.

In that same episode, Charlie and Joe played at being the Wright brothers with some model airplanes intended

to be targets. A sacrilege to the fathers of flight, Wilbur and Orville probably turned over in their graves when they witnessed the initial efforts of Red Jacket's "Wrong brothers." But, just like with "The Meat Chopper," my boys eventually got those planes' wheels up and the client got an experience unlike anything he had expected.

Of course, those are just the main moments of unintended mayhem that've been showcased on *Sons of Guns*. There've been countless lesser fiascos along the way, more than I can possibly remember—and far more than I'll ever admit to, sodium pentothal notwithstanding. And if we keep building things, chances are there are gonna be a hell of a lot more to add to that tally. But that's the nature of the beast, the world of trial and error, and the very reason why I admonish everyone at the start of each show to never, ever, *ever* try this stuff at home.

Fortunately, me and my boys get it right more often than we get it wrong. Then again, if we didn't you'd be watching someone else's ugly mug doing this stuff each week.

The best part of that reckoning: we get to do it all again tomorrow!

I have a love interest in every one of my films—a gun.
—ARNOLD SCHWARZENEGGER

The Guns and Gun Inventors That Changed the World

If anyone's a bigger fan of history than me, point him out and I'll take him behind the woodshed and we'll see who *really* knows his Custer from his Rommel. That's not to say the entirety of my amassed historical knowledge is related to military figures or events, but when you consider that our world's evolution was, is, and always will be directly influenced by the weapons of war, my take on the subject might just give you a different perspective on the way our society was shaped. So without

further adieu, here's my two and a half cents on the guns and gun inventors that changed the world.

No sooner did man come into existence than one of those early humans picked up a rock and bashed another on the head, probably during a dispute over food, shelter, a mate, or maybe the dude with the rock just didn't like the fit of the rockee's loincloth. Hell, it wouldn't be the first time someone got brained for exposing too much skin. Regardless of the reason behind the thumping, from that moment on weapons were recognized as the most effective means to settle a dispute.

A small, hard rock beats a big, soft hand every time. Don't believe me? Smash someone in the face with your bare mitt a dozen times or so and see what that paw looks and feels like afterward. Now, try it with a rock. Understand I'm not encouraging the felon in you, just trying to prove a point.

Following that revelation, simple blunt- and sharp-edged objects, sourced from whatever was lying around—rocks, sticks, bones, etc.—were used whenever grunts and crazed looks weren't enough to get the point across. As such, fights between individuals, and clashes between entire clans, ended much quicker, usually with disastrous consequences for the losers. Second place in an ass-kicking contest ain't no fun.

As time went on, and man learned that attacking his quarry from a distance proved safer and more efficient than up-close-and-personal combat, spears, slings, and bows and arrows came to be. This ultimately led to a host of inventive, premodern projectile contraptions such

as crossbows, ballistae, catapults, and trebuchets, all of which operate on basic principles but use some pretty snazzy engineering—especially considering the era they were created—to get the job done.

The eventual mastery of metalworking brought a whole new range of edged and impact weapons into the mix. Swords, axes, pikes, halberds, knives, daggers, along with the suits of armor worn to defeat them, became the mainstays of battle.

Many thousands of years later, Al Capone would say, "You get more accomplished with a kind word and a gun than you do with just a kind word," proving the age-old theory that whoever has the weapons makes the rules. And that's exactly what unfolded. Suddenly, anyone with a penchant for power and the means—I'm talkin' wealth—to put implements of doom and destruction into the hands of even a semicapable wielder could channel his inner warlord. In the blink of an eye, peasants and farmers were transformed into soldiers just by giving them a weapon.

And then came gunpowder.

Gunpowder was a game changer. It would not only change the way wars were fought, but it would also change the direction in which society progressed. Some say industry changed the face of humanity. Screw that noise. Battle technology set the course of human civilization. Industry just piggybacked itself on battle tech. Gunpowder proves it.

Discovered "accidentally" during the seventh century

by a Chinese alchemist attempting to create an immortality potion for his emperor—if the emperor had drunk it, he would've surely needed to be immortal to survive—the formula didn't see frequent use until about four hundred years later (during the Song Dynasty) when gunpowder was employed as a chemical propellant, first in fireworks and then in firearms, the earliest of which were known as matchlocks.

MATCHLOCKS

Don't listen to any so-called experts who tell you the Chinese invented guns. They didn't. They invented gunpowder, along with a primitive shooting device called a hand cannon, which, for all intents and purposes, was just a miniaturized version of its big brother that graced the gunwales of tall ships or got wheeled into battle atop man- or horse-drawn carts. The only similarity hand cannons share with weapons I view as true firearms—projectile-firing devices with some sort of working action—is that both are portable.

Matchlocks were invented in Europe around 1475; some historians say Portugal while others cite Hungary as the country of origin. Shortly thereafter, improved versions began cropping up in Japan (the Japanese called them *tanegashima*), where they were used by samurai foot soldiers (*ashigaru*), and in India, in the hands of soldiers under Babur the Conqueror. But when I say improved, I'm using that term loosely, as the vast majority of these

weapons were all grits, no shrimp. They were horribly unreliable (a match had to be kept lit continuously to fire them), they were completely weather dependent (if there was any wind or rain, there was likely no flame, and that meant no *boom*), and many were built in a manner that gave them equal odds of exploding in your hand as of actually firing. On top of all that, accuracy was pathetic, although that's being disrespectful to pathetic. Put it this way: you'd have trouble hitting the broad side of a barn if you were standing *inside* the barn. Long story short, you'd have been much better off throwing the matchlock at your enemy or simply using it as a club.

Another aspect of the matchlock's flawed design concerned the ability to sneak up on your enemy or ambush him at night. Wasn't happening. Try hiding in the dark with a match burning. See how that works out for you. Your position would be compromised long before you got close enough to take a shot.

If you know anything about pirates, you may recall that Blackbeard would adorn his beard and head with lit, slow-burning fuses. While that imagery worked for Blackbeard, tromping around with a lit match, even a long, slow-burning fuse, is much easier said than done, especially when you're in the heat of battle and your enemy is doing his damnedest to put you in the ground.

Sum it up any way you want but, technologically speaking, matchlocks weren't. The crux of the design was the serpentine: a clamp at the end of a small, curved lever that held the slow-burning match (often referred

to as a slow match). When you pulled the lever—which eventually got redesigned into a more finger-friendly device known as a trigger—the clamp dropped the burning match into the flash pan, which in turn ignited the priming powder. The subsequent flash went through the touchhole, igniting the gunpowder in the barrel and sending the projectile on its way.

You hoped.

In the scheme of things it was a long-assed process, not the ideal situation when you're facing an oncoming threat. Oftentimes, duels would see the combatants standing around for a few seconds, weapons level, levers pulled, slow match burning, waiting to see whose weapon would fire first—if at all. In some cases the delay was so lengthy, the duelers forgot what they were quarreling about in the first place!

Personally, I'd much rather have a bow and arrow; I know it's gonna work every time I draw the string, which is sure as shit important if your life is depending on it. Also, range and accuracy are far superior. Still, if we're gonna call a spade a spade, the matchlock was a sign of things to come and, when you think about the state of firearms today, one hell of a stepping-stone.

FLINTLOCKS

If matchlocks are the wedding singers of the gun world, flintlocks were, are, and always will be the rock stars.

Developed and introduced at the turn of the seventeenth century, flintlocks are one of the most successful firearm ignition systems of all time and are still used in virtually every corner of the globe, the basic design unchanged after more than five hundred years.

Prior to the flintlock, there was a ladderlike lineage of mechanisms covering two centuries, with each successive rung receiving improvements—some minor, some major—that deserve to be mentioned, if for no other reason than to give the flintlock the props it deserves.

After the matchlock came the wheel lock, an action

that replaced the slow match with a sparking friction wheel. Although significantly better than its predecessor, the mechanism was trickier than a roomful of ninjas and therefore costly to build.

Next came the snap lock, which produced its spark when a spring-loaded cock snapped a flint down onto a piece of hardened steel. Snap locks were the first firearms that allowed a shooter to thumb back the hammer. Had snap locks never been invented, that tension-filled pregnant pause you commonly find in Hollywood action and thriller flicks wouldn't be nearly as entertaining.

This led to the development of the snaphance, an improvement over the snap lock in that the pan cover remained closed, keeping the priming dry until the moment it was to be fired, when it would pop open automatically as part of the process. Snaphances are credited as being the first firearms to incorporate safety mechanisms to prevent accidental discharges. Supposedly the safeties came about because of an accidental shooting (and subsequent death) during Sir Thomas Cavendish's late-1580s expedition to circumnavigate the globe. Then again, I wasn't there. Maybe shooters just got tired of blowing their toes off and decided once and for all to do something about it.

In 1610, French artist and inventor Marin le Bourgeoys built the very first weapon to use a flintlock mechanism for King Louis XIII. That opened the floodgates and soon anyone with the means to commission or purchase one, or the stones to steal one, did exactly that. By 1630, flint-

locks could be found all throughout Europe, in the hands of private citizens and soldiers alike. Flemish baroque painter Peter Paul Rubens is the first artist of note to include flintlocks in one of his works, the painting *Marie de' Medici as Bellona*, created somewhere between 1622 and 1625, and now hanging in the Louvre.

Like the aforementioned painting, flintlocks were also works of art in that they were KISS simple while still being incredibly reliable. Of course, inclement weather, especially rain and snow, could put a crab in the craw of even the finest flintlock, where moisture would quickly turn the powder pan to slush. During the Civil War, opposing fighters were known to take bad weather breaks. Some, especially siblings aligned on opposite sides, would meet in the middle of the battlefield to talk and, incredibly enough, enjoy a game of cards, checkers, or chess until the weather improved and they could commence trying to kill one another again.

Besides shitty weather, flintlocks had other issues to contend with. If a burning ember remained in the barrel after the gun was fired, it could ignite the fresh powder charge as it was being loaded. More than a few people lost their lives because of this design flaw. Misfires, due to poorly napped or dull flint, were common. On that note, all men will attest to the problems that can arise if your gun goes off before it's supposed to. And then there were the sideways sprays of sparks that came blasting out of the flash hole upon ignition. It's for this reason that soldiers were trained to fire in simultaneous volleys to pre-

vent one man's sparks from touching off his neighbor's powder as he reloaded.

But weather limitations aside, flintlocks were a force to be reckoned with. Simply put they worked, which meant when you pointed your gun at someone and pulled the trigger bad things happened to the targeted individual. Common foot soldiers now had a very reliable means of slaying their adversaries. Casualty rates for battles—even small skirmishes—skyrocketed. And when you consider combatants just stood out in the open, directly across from each other in long rows, oftentimes inside of fifty yards, well, you can imagine the scene. Words like ghastly and gruesome come to mind and they don't do it justice.

Flintlocks also played a key role in the very first sniping mission. The earliest-known sniper was Timothy Murphy, a Pennsylvanian who during the Revolutionary War was one of five hundred handpicked riflemen—the sharpshooter corps, all could hit a seven-inch target from a distance of 250 yards—selected by General Daniel Morgan to help put a stop to the advancement of General John Burgoyne and the British army in Upstate New York.

During the Battle of Saratoga, where the Brits were getting their tails kicked, Brigadier General Simon Fraser began to rally the English Crown's troops and seemed about to turn the battle's tide. That's when notorious traitor Benedict Arnold rode up to General Morgan, pointed out across the battlefield at General Fraser, and said the man was as valuable as an entire regiment. Immediately, Morgan called on his most skilled shooter, Murphy, and

uttered these famous words: "That gallant officer is General Fraser. I do admire him but it is necessary that he should die. Do your duty."

Murphy took this task to heart. He climbed one of the tallest trees he could find, lined up on his target roughly three hundred yards away—a ridiculously long distance for the time—and fired four shots. The first round missed. Close, but a miss nonetheless. The second round nicked Fraser's horse. Shot number three found its mark, drilling Fraser in the stomach, knocking him clean off his horse. Now dialed in perfectly for the distance, Murphy's fourth shot scored a direct hit on the British senior officer Sir Francis Clerke, General Burgoyne's personal assistant, killing him instantly. As for Fraser, he was taken by medics from the battlefield but succumbed to his wound later that night.

An interesting footnote of history involving the flintlock: During the Battle of Brandywine Creek, Captain Frederick Peterson of the Seventieth Regiment Afoot, the British's company of expert marksmen, had an American general lined up in his rifle's sights. But before he could pull the trigger, the general turned and rode off. Ferguson later went on record as saying he thought it unsporting to shoot the man in the back so he elected to let him go. As it turns out, that general was none other than the father of our country, George Washington.

When it comes to ammunition, most flintlocks were smoothbore and fired round balls in a wide range of calibers: the pea-size .32 (they were called "pea rifles" be-

cause the ball was about the same size as a pea), perfect for small game; .50 and .54, ideal for quarry of the two-legged, upright-walking variety; the positively huge .75 and .79, which were often loaded with balls of different sizes; and the bowling-ball proportion 4-bore (equates to 1.0 caliber), a veritable monster killer used for the biggest of big game on the Dark Continent that dispensed a recoil that was exactly what the masochist ordered.

Barrel lengths for rifles ranged anywhere from eighteen inches all the way to fifty inches and beyond. For pistols, they went from mere nubs (riverboat gambler specials) to sixteenth-inch models specifically made (usually in pairs) for dueling.

As the quest for greater accuracy (especially over longer distances) continued, gun makers began to add spiral grooves known as rifling to their weapons' barrels. But with the increased accuracy came longer load times; balls fit tighter and were harder to ram down the barrel. Also, after a few shots, powder would cake the grooves—called fouling—and had to be cleaned or else the gun wouldn't function properly.

Clearly, flintlocks leave much to be desired when compared to modern weaponry. But for those sportsmen and hunters looking to get all Jeremiah Johnson and connect with the outdoors in the same manner their ancestors did, a flintlock rifle—especially one you've had the pleasure of building or engraving yourself—is an experience that's hard, if not impossible, to match.

THE GATLING GUN

The Gatling gun ushered in a new era of weapon technology: sustained automatic fire. When you consider the times and put it into perspective, those who wielded the Gatling gun were akin to a god among mortals.

Invented by Dr. Richard J. Gatling in 1861, it was said the weapon's true purpose was to illustrate the futility of war because in combat, unless the gun malfunctioned or its operator were taken out, no one that opposed it stood a snowball's chance in hell.

Utilizing a multibarrel design in which each barrel fired in sequence, ejected the spent casing, and was immediately reloaded automatically, barrels were given the opportunity to cool for a few moments before being called upon to fire again, prolonging the weapon's combat effectiveness. But because the action was cycled manually via hand crank, in the eyes of engineers and historians

alike it wasn't a true full auto like the Maxim gun, which wouldn't make its debut until two decades later.

The Gatling gun first saw battlefield action during the Civil War; the Union army used it with devastating effectiveness. Physical capabilities aside, imagine the psychological terror of going from facing soldiers firing one shot at a time to a device that could spit out six hundred .58-caliber rounds per minute—one hundred rounds per minute from each of its six barrels.

Amazingly, it took five years before the gun was "officially accepted" by the American army. Issues with fragility and the weapon's considerable expense—they were selling for a thousand dollars apiece at the time—coupled with inconsistent velocity and accuracy, and less-than-stellar barrel to chamber alignment, reduced it to more of a novelty than a necessity. But problems aside, in the eyes of anyone pitted against it, it was like staring down the devil himself—usually with the same results.

During the Spanish-American War, the Gatling gun played an important role in the most brutal and bloodiest skirmish of the conflict, the Battle of San Juan Hill, in which future president Theodore Roosevelt and the Rough Riders—the moniker given to the First United States Volunteer Cavalry—made a name for themselves.

Fans of Westerns and Clint Eastwood will recall the scene in *The Outlaw Josey Wales* when Clint's Missouri farmer-turned-vigilante title character uses a Gatling gun to exact payback on a bunch of Kansas "Redlegs," the pro-Union Jayhawker bastards that killed his wife and

son. Another odd historical footnote: in 1877, Gatling's next-door neighbor in Hartford, Connecticut, was Elizabeth Hart Jarvis Colt, widow of Samuel Colt, the founder of Colt firearms, whose factory had been contracted to manufacture Gatling's guns. I guess birds of a feather really do flock together.

WINCHESTER LEVER ACTION RIFLE

While Winchester certainly deserves all the accolades it has amassed over the years, the gun that started it all, the Winchester repeater, whose action was cycled by a lever, wasn't a fresh-from-scratch concept but rather a design that improved on another already in existence.

The first attaboy goes to inventor Walter Hunt, who patented the Volition Repeating Rifle in 1848. His rifle had a tubular magazine and a pair of levers. The ammunition was called rocket ball, among the earliest caseless ammo on record.

In what amounts to a tag team approach to weaponry, one year later Lewis Jennings bought Hunt's Volition patents, made some changes, and produced his own version of the weapon courtesy of the Robbins and Lawrence Armory and Machine Shop in Windsor, Vermont, which would become a national historic landmark in 1966.

Two names that are synonymous with guns—Horace Smith and Daniel Wesson—both of Norwich, Connecticut, purchased Jennings's patents from Robbins and Lawrence a few years later. For that transaction to take place,

another palm had to be greased—shop foreman Benjamin Tyler Henry, whose name is also forever etched in the annals of American firearm history.

Smith and Wesson improved the Jennings design considerably, and with the help of some investors—the largest shareholder being Oliver Winchester—formed the Volcanic Repeating Arms Company and put their lever action rifles and pistols into production. Success was limited, however, and soon Wesson left for greener pastures. Less than a year later Smith followed and quickly teamed up with his old friend and fellow gun visionary to create the Smith & Wesson Revolver Company. I'm guessing you've heard of 'em.

Still enamored with the concept, Henry continued to work on and perfect the design while simultaneously developing a larger, more powerful cartridge—the .44 Henry. In 1860, the New Haven Arms Company began production of the Henry Rifle, which found its way into scores of Union army units during the Civil War, the majority purchased by the soldiers themselves. With its impressive ammunition capacity, excellent reliability, and superlative accuracy, Henry rifles were a prized possession and a great many Confederate soldiers were reduced to worm food because of 'em.

When the War between the States finally ended—claiming well over six hundred thousand lives in the process, more than any other war or conflict in which America was involved by an enormous margin—Oliver Winchester changed the name of the New Haven Arms

Company to the Winchester Repeating Arms Company and their primary product, based largely on the Henry rifle, was the Winchester Model 1866, a gun that had a profound effect on the current state of the world. An example of this effect was readily apparent in the raging Russo-Turkish War. During one battle, despite being badly outnumbered, the Turks kicked the living shit out of the Russkies, inflicting four times as many casualties. This landslide proportion of death nearly caused every world superpower to dump their single-shot weapons in favor of repeating rifles.

But the best was yet to come. And seven years later, it did.

The Winchester Model 1873—the Gun that Won the West—was not only rugged and accurate, but it also allowed owners to carry a pistol chambered in the same caliber, .44-40. The Model 1873 was the popular choice among frontiersmen, and, more than just a rifle, it became a bona fide American symbol. Buffalo Bill nicknamed it the Boss and Captain Edward Cathcart "Ned" Crossman, arguably one of the most prolific and famous gun writers of the twentieth century, called it "the rifle that put Winchester on the map of the West." Thirty years after that quote, Jimmy Stewart and Shelley Winters would star in the Hollywood Western *Winchester '73*, about a prized Model 1873, which also featured performances by future movie stars James Best, Tony Curtis, and Rock Hudson.

Future models offered numerous improvements: heavier frames for one, along with a wider range of calibers—everything from .22 rimfire to the behemoth

.50-110 Express, suitable for hunting buffaloes or bulldozers. Worth mentioning, the Winchester Model 1894, the bulk of which were chambered in .30-30, is one of the best-selling hunting rifles ever made and the first sporting rifle to sell more than one million units. The final tally for the Model 1894 before it went out of production in 2006 is more than seven million!

While automatics cycle faster and because their removable extended magazines hold more rounds, and while bolt actions are inherently more accurate and capable of being chambered in much larger, more powerful cartridges, lever actions like the Winchester will never fall out of favor with gun enthusiasts of all ages and skill levels. Taking it a step further, the love for the Winchester lever action is so strong that in many cases the "cowboy gun" is the preferred weapon of choice even when cost or caliber is not a prohibitive factor. If that ain't loyalty, I don't know what is.

JOHN M. BROWNING

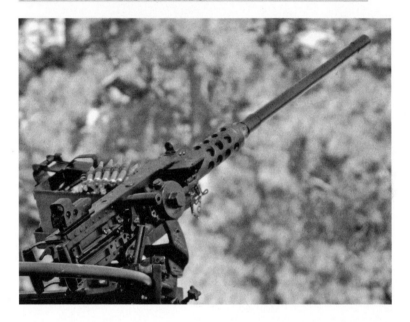

First things first, I'm not talkin' about the poet. Not that I don't have a healthy amount of respect for anyone who can compose a snappy sonnet, but the man I'm referencing worked with metal, not words. Like Moses, the most important prophet in Judaism, John Moses Browning is, in my not-so-humble opinion, the most important figure in the development of modern arms.

Browning started working in his dad's gun shop at the tender age of seven and made his first gun at the age of thirteen. Think about that the next time your kid suits up for Little League. At the time of his death in 1926, he held 128 firearm patents; his first, the Model 1885, was

bought by Winchester for eight thousand dollars, setting the stage for many collaborations with Winchester in the years to come, among them the previously mentioned best-selling Model 1894 lever action.

Single-shots, lever actions, pump-actions, bolt actions, semiauto, full autos, pistols, rifles, shotguns—there isn't one category or subcategory of firearm that Browning didn't have a major influence on. Had he lived another hundred years, I'm sure he would have had a major part in the development of the ray gun, too.

But of all his creations, the one that captured the hearts and holsters of the gun world more than any other— maybe more than all the others put together—went on to become the most widely used (and copied) handgun in existence, the M1911 pistol.

Single-action, semiautomatic, recoil-operated, and magazine fed, the beauty of the M1911 is in its simplicity. But Browning didn't just design the gun; he also designed the round it fired: the .45 Auto (also known as the .45 ACP, Automatic Colt Pistol). Larger, heavier, and slower in comparison to its military service sibling, the 9mm Parabellum (9x19, 9mm Luger, 9mm NATO), some gun experts lovingly refer to the .45 Auto's hollow-point bullets as flying ashtrays on account of how they look and hit.

While the gun's design first came about in the 1890s, it wasn't accepted into military service until 1911 when the Unites States Army made it their official sidearm. Two years later, both the navy and the marine corps followed suit. From 1911 until 1985 it was the standard issue side-

arm for the entirety of the US armed forces and, as you'd expect, saw heavy use in WWI, WWII, the Korean War, and the Vietnam War, along with every minor and major conflict or skirmish in between.

Today, whether you've got a five-hundred-dollar no-frills GI model or a five-thousand-dollar all-the-bells-and-whistles race gun, the pistols share a common bloodline with an internal structure that is, for the most part, identical.

Another major Browning contribution was the BAR, otherwise known as the Browning Automatic Rifle.

When we entered WWI, we were woefully unprepared in the weaponry arena, our infantry troops using guns supplied by the British and French, the bulk of which were factory seconds or surplus weapons. Addressing the need for a dependable weapon that would also be a consistent man-killer, Browning conjured up a shoulder-fired automatic rifle known as the BMR—Browning Machine Rifle.

Using the .30-06 Springfield cartridge, a round that proved itself many times over in the years to come in sporting applications, especially among deer hunters, the BMR could be individually shoulder slung and, when needed, fired reasonably accurately from the hip or if more accuracy was desired, positioned prone with its bipod deployed. On February 27, 1917, Browning staged a live-fire demo at Congress Heights in Washington, DC, for approximately three hundred congressmen, senators, high-ranking military officers, foreign dignitaries, and, of course, members of the press. Pardon the pun but Browning blew the audience away and was immediately

awarded a contract. The weapon would go into service as the M1918 Browning Automatic Rifle (BAR).

From the moment it hit the battlefield, the BAR made an impact, most notably with the Seventy-Ninth Infantry Division. In a bizarre twist of fate, Browning's only son, Second Lieutenant Val Allen Browning, is said to be the first soldier to use the BAR against the enemy. The allied French forces were so impressed with the new weapon they immediately ordered fifteen thousand of them to replace their undependable Chauchat machine rifles.

Now it's time for the big daddy of Browning's contributions—the .50 Browning Machine Gun.

At the start of WWI, American troops didn't have much in the way of machine guns, and what they did have used smaller-than-desirable cartridges. The British and French had bigger guns. So did our enemy, the Germans. This led General John J. Pershing, commander of the American Expeditionary Forces, to push for the fast-track development of a machine gun of at least .50 caliber and a muzzle velocity no less than 2,700 feet per second, what he believed was needed to defeat the enemy's armor plating.

Not one to turn down a challenge, Browning went back to his drawing board and immediately began redesigning his .30-caliber machine gun to accept a larger round while Winchester went to work on the cartridge, using the .30-06 as its starting point.

The first .50 machine gun made its debut on October 15, 1918. Sadly, for all involved, especially those on the engineering side of the equation, it was an underwhelm-

ing performance. Muzzle velocity was just 2,300 feet per second—400 fps below the target speed—and the firing rate was less than 500 rounds per minute. On top of that, the gun was extremely heavy and difficult to control.

Shortly after the field test, a cache of German antitank rifles and ammunition was captured. A thorough study of the seized ammo led to numerous improvements in the Winchester .50 round, including a serious bump in muzzle velocity—up to 2,750 fps.

Browning worked his magic and the M1921 water-cooled Browning machine gun was the result. An improved version, the M1921A1, came out in 1930, four years after Browning's death, which featured a trilegged pedestal mount, thirty-six-inch barrel, and boasted a cyclic rate that maxed out at 650 rounds per minute.

But the improvements didn't stop there.

Eventually, a lighter, more easily portable air-cooled, belt-fed version—the M2—was taken to market, giving soldiers a weapon that could be used in both antipersonnel and antimatériel (a.k.a. hard-target interdiction) scenarios.

Often referred to as Ma Deuce or simply the fifty, the .50 BMG has seen extensive action from the moment it was introduced in 1933 until today, factoring heavily in every major war and conflict during this span.

With an effective range greater than two thousand yards, during the Vietnam War, US Marine Corps sniper extraordinaire Carlos Hathcock (a.k.a. the White Feather) converted the big machine gun to semiauto, mounted a Unertl telescopic sight on it via a specially built bracket

of his own design, and began engaging targets at distances more than twice the maximum range the then-current sniper rifles—Winchester Model 70 chambered in .30-06—were attempting. His longest confirmed kill, an astounding 2,460 yards (1.3 miles), was a record that stood until 2002.

Ask any current active duty infantryman about his feelings toward the .50 BMG and I'd bet, to a man, all would feel naked and vulnerable if their unit went into battle without Ma Deuce in the battery.

MG 42

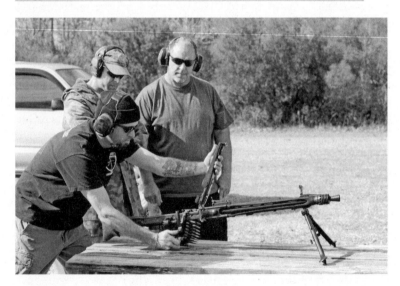

Maschinengewehr 42, a.k.a. Machine Gun 42, is a belt-fed 7.92x57, recoil-operated, roller-locked, man-portable machine gun known for its simplicity, reliability, and staggering rate of fire—in the realm of fifteen hundred

rounds per minute—with a maximum range of a thousand meters.

Introduced in 1942 during WWII following a three-company competition to replace its predecessor, the MG 39, the MG 42 was easily the most feared German infantry weapon in the Wehrmacht arsenal. Nicknamed Hitler's Zipper and Hitler's Buzzsaw by those who faced it (German troops called it the bone saw), its distinctive sound was so terrifying—the earsplitting "ripping cloth" crescendo caused many American GIs to stop in their tracks or turn back the way they came—the US Army produced specialized training films to help soldiers prepare to face it in combat. And even after Nazi Germany's eventual defeat, the MG 42 remained, eventually spawning the Swiss MG 51 and SIG MG 710-3.

More than four hundred thousand MG 42s were produced from 1942 to 1945 and a great many are still around and working today, a testament to the weapon's durability.

EUGENE STONER AND THE AR-15/M16

The man behind the AR-15/M16, Eugene Stoner, is regarded as one of the world's three greatest firearms designers, the other two being the aforementioned John Browning and the still-to-come Mikhail Kalashnikov.

Following a brief stint at the Vega Aircraft Corporation, a subsidiary of Lockheed, where he installed armament in military aircraft, Stoner enlisted in the marine corps during WWII, opting for aviation ordnance, and

served in both Northern China and the South Pacific. After the war, he continued on his path in aviation engineering by working as a design engineer for Whittaker Guns. This ultimately led to the position of chief engineer for the American arms company, ArmaLite, where he designed a series of prototype small arms: AR-3, AR-5, AR-9, AR-11, and AR-12, with AR standing for ArmaLite Rifle. Of these, only one achieved any real success, the AR-5 survival rifle, which the US Air Force adopted.

In 1955, only a year after joining ArmaLite, Stoner introduced his AR-10 design, a groundbreaking lightweight, select-fire infantry rifle chambered in 7.62x51 NATO, nearly identical to the .308 Winchester. Although the AR-10 was smaller, lighter, and easier to control during full-auto fire than the rifles it was being tested against at the army's Aberdeen Proving Ground trials, its late arrival ultimately led to its rejection in favor of the M14.

However, the AR-10's capabilities and unconventional design found an ardent fan in the Dutch firm Artillerie Inrichtingen, which licensed, produced, and sold it to a host of foreign militaries until 1960 when Stoner's chief assistant, Robert Fremont, and firearm inventor Jim Sullivan, working together at the behest of the US military took the AR-10 platform and scaled it down to accept the .223 Remington cartridge, thereby creating the AR-15, which would eventually go into military service as the M16.

Capable of three different rates of fire—semiauto,

full auto, and three-round burst—the M16 seemed the ideal platform for American troops courtesy of its light weight, high round capacity, ease of use, and the round's low recoil and flat-shooting trajectory. Even those unfamiliar with the rifle—or any rifle for that matter—could achieve consistent hits on man-size targets at combat distances in relatively short order. That's not to say the weapon was perfect. Far from it. Early versions were prone to jamming due to a "failure to extract" flaw, in which spent brass lodged in the chamber. This was blamed on an inconsistency in the supplied ammo's powder. Another problem that seemed to plague the M16 concerned its reliability when dirty. Fortunately, fieldstripping and cleaning the rifle was an easy process, even for a novice, though many would argue that the wet, tropical conditions of the Vietnam jungle made it impossible to keep M16s functioning at optimum levels.

Since its introduction during the Vietnam War, the M16 and its many variants has remained the official service rifle of all branches of the US military. As of this moment, the AR-15/M16 and its siblings are used in more than eighty countries, with companies in the United States, Canada, and China responsible for the production of more than eight million units, about 90 percent of which are still in operation.

MIKHAIL KALASHNIKOV AND THE AK

By the time you finish reading this sentence someone in the world will have been killed by an AK-variant rifle. It is a sobering thought for sure but a cold hard fact nonetheless. The statistic I just quoted hinges on the reality that the AK-47 and its brethren are the most popular so-called assault rifles in the world, currently in service with the standing armies of eighty-two different nations, and the weapon of choice with innumerable militias, private armies, soldiers of fortune, and virtually anyone else with a need for a do-it-all small arms rifle. This is largely due to the reasonably accurate caliber (7.62x39) found in abundant supply around the globe, design simplicity, and overall heartiness. Quite simply, this weapon will function in just about any conditions imaginable.

Historians note an interesting parallel between the AK's toughness and that of its inventor, Mikhail Kalashnikov, who was on death's door at age six, suffering from a number of serious illnesses and wholly dependent on medical machines to keep him alive. But survive he did, and while working as a mechanic at a tractor station in his early teens he saw his first detailed firearm schematic and instantly fell in love with weaponry—what it could do and, perhaps more important, what it was capable of doing if properly modified.

In 1938, after being drafted into the Red Army, Kalashnikov's diminutive size coupled with his engineering acumen netted him the job of tank mechanic; he would

go on to become a tank commander. His earliest inventions came during the training phase of his service, and Georgy Zhukov, marshal of the Soviet Union, was so impressed he gave Mikhail a wristwatch. But were it not for injuries sustained in combat during the Battle of Bryansk in 1941, Kalashnikov's greatest contribution may never have seen the light of day.

While recovering in the hospital, he heard other wounded soldiers complaining about the inadequacies of current Soviet rifles and decided to make it his mission to give them a weapon they could trust. Although his first foray into the small arms arena—a submachine gun—wasn't declared fit for service, Mikhail's creative talents did not go unnoticed and he was immediately reassigned to the Central Scientific-Developmental Firing Range for Rifle Firearms of the Chief Artillery Directorate of the Red Army.

Two years after arriving at his new post, Kalashnikov designed a gas-operated carbine to be used as a platform for the recently developed Soviet cartridge, the 7.62x39, a round that unlike any of its international competitors could be used without issue in a wide range of climates and temperatures—arctic cold to desert heat.

Once again, Kalashnikov's creation came up just short; this time the Simonov carbine—which would gain fame as the SKS—beat him out. However, his prototype weapon, the Mikhtim—a combination of his first and middle names—became the basis for his ultimate creation, the Avtomat Kalashnikova model 1947: the AK-47. With

their many years of experience, his superiors—Vasily Degtyaryov and Georgy Shpagin—knew a world-beater when they saw one and sang the new gun's praises. As such, the weapon was rushed into production.

Well over a hundred million AKs and AK variants have been built since the gun first came to fruition (nearly half of which are built outside of Mother Russia) and Kalashnikov's list of awards and accolades is longer than all the Dead Sea Scrolls combined. Some of these include the Order of Saint Andrew the Protoclete, the Hero of Socialist Labour (twice), the Order of Lenin (three times), and the Order of the Red Star. On his ninetieth birthday in 2009, he was named a Hero of the Russian Federation and given a medal by President Dmitry Medvedev who praised Mikhail for "creating the brand every Russian citizen can be proud of."

Yet for all his accomplishments and storied achievements, inventing the most prolific assault rifle haunts Mikhail Kalashnikov to this day. During an interview in 2002, he was quoted as saying, "While I'm extremely proud of my invention, I'm sad it is used by terrorists. I would prefer to have invented a machine that people could use, such as one that would help farmers with their work, for example a lawn mower."

Both oligarch and tyrant mistrust the people, and
therefore deprive them of arms.
—ARISTOTLE

Reality TV: What Ya See
Is What Ya Get

The inability to pay your bills, the inability to feed
your family, the inability to afford medicine: that's
a reality many Americans—and many others
around the world—deal with on a daily basis. A harsh
reality. The reality of life. And for those of us who've
been there, or are *still* there, climbing out of that hole
feels like trying to pole-vault out of a mile-deep canyon.
But in recent years, the mention of "reality" brings to
mind very different scenarios. Some examples are:

Sixteen perfect strangers are willingly "stranded" on a tropical island to play some silly games, damn near starve to death 'cause they lack the basic skills to make fire or source food from their environment, all the while conspiring to vote each other off one at a time, leaving the last one standing to receive a million-dollar prize.

And then there's that family with the long-assed name. You know the one—mostly sisters, pretty girls, rather well-endowed, big booties, their fame coming courtesy of one of them gals lettin' her sex tape go mass-market— and now they've got cameras following them all day and night, filming their manicures and pedicures, Brazilian waxes, arguments about boob jobs and butt lifts, and all the other trivial things that seem to dominate their lives.

Or what about those tough-as-nails fishermen who routinely brave the elements in one of the most unforgiving places on earth—the Bering Sea—to find, catch, and secure a living product that people around the world will shell out big bucks for just as long as it comes with a side of melted butter.

And then there's me and the rest of my so-called Sons of Guns, who turn scraps of metal into works of art— very dangerous works of art that can be used for anything from engaging in a hobby that's been around for centuries to putting food on the table to protecting your crib to starting (or finishing) wars.

According to the newspapers and magazines, *we*—and many others like us—are the new reality. And while I find it incredibly puzzling that folks would rather sit on

their butts and watch other regular folks live their lives instead of going out and livin' their own, I'd be lying if I said I didn't appreciate the attention. Heck, more than just appreciate it I embrace it with a grizzly bear hug. After all, my company's very existence—and therefore the roof over my family's head and the food in their bellies— is largely dependent on our show's ratings.

Still, by my very nature, the way I was raised, my life experiences and all that, I don't consider myself or any of my boys celebrities. No way, no how. The moment I see any of 'em "going Hollywood," the very next moment they'll be lookin' for a new job, I promise you that.

To be fair, I can see why our fans have put us on a pedestal in a manner of speaking. Now, I'm not saying we should be called in to give commencement speeches, do opening-day ribbon cuttings, throw out the first pitch at major-league ball games, or toss the coin at the Super Bowl—if you want to invite us, don't let me stop you— but from a visual buffet and kick-ass cool standpoint, what me and my boys do isn't for the uninspired, and it certainly ain't for the faint of heart. We work in oh-so-close quarters with things that go *bang* and *boom*, most of the time controlling those explosive reactions right up until the exact moment we want them to greet the rest of the world. It's scary work to be sure, where life and death, pain and suffering, absolute perfection and complete failure are usually within a nanometer of one another. But we love it. And much as I hate to brag, we've become pretty dang good at it, too.

That leads me to this, a generalization about *Sons of Guns* and reality television as a whole: what ya see is what ya get.

Every now and then I hear people say things like "editing wizardry" and "the magic of Hollywood" and "sur-reality." That may be the case for movies and such but last I checked reality and fiction were two separate worlds. If you don't say it or you don't do it, it just ain't gonna appear on television. Now, there are times when we say and do things that we *wish* we hadn't—oh hell, I can ramble a few hundred of those off the top of my head—but if the cameras are rolling, all you can do is man up and take ownership of it.

The camera don't lie.

We don't work with green screens and computer-generated images and special effects technicians. Trust me. It ain't in the budget. If it were I'd have a bit more hair, a bit less midriff, and a crew that did *exactly* what they were told the first time, every time. But like I said, that ain't reality.

Prior to *Sons of Guns*, the only way you'd get me to tune in to a reality show was if you Tasered my ass, dragged my limp body over to a TV, and tied it to stakes embedded in the ground 'cause when I came to, no friggin' way would I stay put. So as you can imagine, going from despising reality to "starring in it"—man I hate that, I really do—took some getting used to, but here I am. And each week I keep coming back for more.

However, while I'd like to think me and my boys haven't changed since the show began, the same can't be said for the world around us, at least in terms of how the rest of the world perceives us or relates to us. Because of the show, millions of people around the world now know who we are and, love us or hate us, they ain't shy about saying *exactly* what they think. But more than just sharing their thoughts on gun-related topics, the places we should go on vacation—vacation, what is a vacation?— or what we should do to our mothers and farm animals, they weigh in on the projects we should undertake.

Not a day goes by that we don't receive a slew of calls, e-mails, letters, telexes, smoke signals, carrier pigeon communiqués, and every other form of message under the sun regarding the weapons we should build next. Either they want us to take on a custom project specifically for them or simply because the object they're describing would be "bitchin' to see on the retail market" (their words, not mine!).

Now, some of these conceptualizations we're implored to design and build are quite interesting and, dare I say it, would likely serve a legitimate purpose and quite probably receive mass-market acceptance. Remember, I said some. For the vast majority, however, words escape me, although "yeesh" works quite well. I'll go out on a limb and say that there are more than a few rubber rooms and straitjackets missing their occupants.

Allaying blame where blame is due, we're partly/

mostly responsible for this influx of craziness. Our company motto—"If you can dream it, we can build it"—encourages it for sure. 'Course, I'd like to place an addendum on that slogan. Something like—"unless it's illegal or completely insane"—but what fun would that be?

Think I'm kidding? Judge for yourself.

Among some of the harebrained projects we've been asked to take on are blenders that can be *Transformer*-ized into Gatling guns and toasters that in addition to toasting bread, muffins, and anything else you stuff in the slots can pull double-duty as flare guns and short-range mortars.

Creative? Yes. Taco short of a combo plate? Absolutely.

One of my personal favorites was the idea for a guitar that can be disassembled into a soup-to-nuts Clandestine Assassin's Carryall. This unique weapon system would feature everything from garrotes (strings) to a tactical club (neck) to throwing knife–type weapons (frets) to a bulletproof shield (body). And while I'm sure there are a few musicians out there who might want such a thing—Ted Nugent would probably love one of these!—I can't in good conscience set about creating something that would transform Dave Matthews into a war machine.

But wait, there's more.

One of our more die-hard fans with a penchant for pistols dreamed up a three-barreled, three-cylinder revolver, the cylinders operating on some type of bizarre *Wild Wild West* inner-rotating mechanism that mechanically speaking makes about as much sense as boobs on a bowling ball.

Another guy, because he saw it in some wacky Elmer Fudd cartoon or some shit like that is absolutely determined to have us build him a double-barrel *pump* shotgun.

Really? And the purpose for this would be?

And then there's the assortment of megacaliber hunting handguns and rifles we're begged to build so folks can go on Bigfoot and Loch Ness Monster safaris with the absolute confidence of knowing they have a weapon capable of putting the big beasts down for the count if and when (yeah right) they find 'em.

One potential customer was so convinced the Apocalypse was coming in the form of invaders from beyond our galaxy that he wanted an E.T.-qualizer—an over/under rifle/shotgun combo with a ray gun attachment that could be set to stun or disintegrate. Good news was that he was already hard at work on the ray gun. I let him know that as soon as his component of the weapon was complete, bring it on in and we'll install a rail to attach it. Oddly enough, I haven't heard from him since 12/21/12. Go figure.

Let me just say that while I appreciate y'all taking time out of your busy schedules to pitch us ideas and offer us potential business, and while I am continually impressed by the levels of creativity (read: *insanity*) out there, just because something *can* be built doesn't mean it *should* be built.

Not that I feel the need to apologize but please don't take my tone the wrong way. I am tickled pink that

viewers think highly enough about our show and what we at RJF do to take the time to write in with their mind's eye inventions we should consider building to change the world or help us invade unsuspecting countries. After all, Canada very well might be susceptible to a sneak attack by special ops soldiers armed with turkey basters that can be converted into miniature ICBM silos. I mean, c'mon, who woulda thunk it? But in the grand scheme of things, when we're undermanned as it is, just trying to deliver the next batch of Saiga-12s or ZK-22s or any of the other *normal* items we build and sell, bogging down our production to a field of molasses standstill for an all-hands-on-deck design, mock-up, and build of an object that probably won't work—but even if it does will have zero use in modern society and absolutely no commercial value whatsoever—ain't the wisest course of action.

Speaking of production, that's another aspect of reality—*my* reality—that deserves a mention.

Watching the show you'd think Red Jacket Firearms is a major manufacturing powerhouse. Nothing could be further from the truth. News flash: we are not Smith and Wesson. Heck, we're not even Smith and Wollensky. Our "assembly line" consists of whoever is standing at their bench at the exact moment that something needs to get built. We're the very definition of the little guy just trying to survive. Unfortunately, the success of the show has made us look much bigger, much more "large-scale-project capable" than we really are.

Flattering? Yes. Troublesome? Most definitely.

Delivering a single prototype rifle for the military with all the bells and whistles—that won't implode or explode—in an extremely short amount of time is one thing. Building a couple hundred thousand of those rifles isn't just a whole new kettle of fish. It's a freakin' ocean of marine life! Our shop's the size of an average—hell, maybe even small—fast-food joint. It is *not* an every-machine-under-the-sun factory. We're beyond grateful for the TV exposure that's made us look like rock stars. Problem is we still have the functional manpower of a garage band. This perception of our size and capability has resulted in some negative feedback as of late concerning our inability to meet the demand for our products, or for some custom work we've been entrusted. I can't say enough how much I appreciate your business. Please just bear with us. Rome wasn't built in a day. The same goes for our weapons. We'll get there. Just give us time. The end result will be worth the wait. That I can guaran-damn-tee.

Another aspect of reality television as it relates to *Sons of Guns* that needs a mention is the timelines. By that I mean the time it takes to go from a wild-hair-up-your-ass concept to a functional prototype that actually does what it's supposed to do. But before I get into that, please allow my quick but necessary detour.

Currently, there are only two reality shows on television that focus on companies that make a retail product: *Sons of Guns* and *Duck Dynasty*. Prior to the show, the *Duck Dynasty* boys were already, well, a dynasty. Their

products were selling like hotcakes and French toast in a land that only served breakfast, making them all very successful. Freakin' millionaires! We, on the other hand, weren't in that high-society niche. And trust me; we still ain't. Far from it. Before the show, most folks—even die-hard gun enthusiasts—didn't know we existed.

But popularity or anonymity doesn't have an itty-bitty ant's titty to do with the amount of time it takes to bring a product to market. From conception to production is a hell of a long time. Months, sometimes years. But we build stuff—the kind of stuff that really shouldn't be built that fast, mind you—in weeks. Sometimes even in *days*. We have to. The world we live in has been relegated to sound bites, where ten seconds is an eternity. Sales pitches used to be an hour or more with all sorts of supporting graphs and charts, imagery and who knows what else. Now it happens during an elevator ride. A one-floor elevator ride.

As I'm learning, in the realm of television—reality TV especially—speed is essential. If it drags, you're toast.

You remember that Western gunfighter flick with Leo DiCaprio, Gene Hackman, Russell Crowe, and Sharon Stone? *The Quick and the Dead.* The bare essentials of that movie's plot translate perfectly to the requirements of successful reality television. If you ain't quick—if your story lines take too long to develop—your show is dead. But when you're building weapons—bona fide human-slaying objects of destruction—where projectiles rip through barrels at over three thousand feet per second,

there's a lot more to it than just grabbing a couple pieces of metal, welding them together, slapping some paint or polish on it, and calling it a working gun.

There are metallurgy studies to determine what type of steel should be used, or how thick it should be, or the proper rates of twist in the barrel for accuracy, or what you're going to use to hold the barrel in, or what type of screws you'll use—if you use screws at all—when dealing with the abstract bottom frame or . . . Shit, I could go on forever with the number of criteria that need to be considered before even attempting to design anything resembling a firearm let alone building it to the point it doesn't turn into a grenade when you pull the trigger.

Long story short, we do the impossible. Consistently. Yet when you see a finished episode, in which the full gestation of a product occurs during forty-two minutes, the insanity of what it took to achieve that result often gets lost in the shuffle. Hell, if you knew what it took just to build a weapon that can successfully deliver a five-round burst without going all cattywampus you'd soil your trousers.

Yet somehow we manage to get it done. And you, the fans, like it enough to keep coming back for more. For that I offer both my thanks and this promise: you'll never see anything on *Sons of Guns* that ain't real. Trust me. My boys' egos will never outgrow their hats. I've got vices in the shop to see to that. Lock in their noggins between the plates, spin the crank, and—oh yeah, they'll get the message. Of course, we may add a little extra boom

powder to a target every now and then just for shits and giggles—if you think monster explosions, followed by a small inferno and gobs of smoke looks good on TV you should see it in person—but hey, that's on me. I figure if I'm gonna be a bear, you're damn skippy I'm gonna be a grizzly.

We may find in the long run that tinned food is a
deadlier weapon than a machine gun.
—GEORGE ORWELL

Stephanie Hayden:
The Original Gun Girl

I can't say enough about how proud I am of Stephanie.
Proud of her as my daughter. Proud of how she is as
a mother. Proud of how she is as a businesswoman.
Proud to be her business partner. Proud of her as a human being in general. Not in my wildest dreams could
I have ever imagined that my little girl would grow up
to be as amazing and dynamic as she turned out to be.
I could gush on her until alligators turn into alley cats

but I'll just end up embarrassing her or tripping over my tongue—or both—so it's probably best to let her tell you her story.

Contrary to popular belief I didn't grow up putting jungle fatigues, ammo bandoleers, and slung machine guns on Barbie Dolls. I didn't *play* with Barbie Dolls!

As a kid, my dad didn't start me with guns. The first weapon he gave me was a bow and arrow. He also gave me a horse.

"Learn on these," he said. "Not just how to use them but the responsibility that comes with owning them. When you've got that down, we'll see about moving up to something else."

He was teaching me a lesson and I didn't even know it. I just saw the bow and arrow and the horse as incredible gifts. But he was instilling the crawl-before-you-walk concept by giving me things that were potentially dangerous and, in the case of the horse, this big animal that required a lot of work. So not only did I have to respect what they were and the work that was required, but I also had to respect what both were capable of: if I were foolish or careless with either, I could have been hurt or killed. That's not to say he wasn't monitoring me, but he wasn't holding my hand every second of the day, either. Some things you gotta learn to do on your own.

That bow and arrow gave me experience with a type

of weaponry that I probably never would have had if he hadn't pushed it on me. As such, it led to me having a much greater appreciation of guns.

When you're a little kid and you get a bow, you suddenly have a little power and it's a really cool moment. By the same token, if I had been given a gun instead—like a lot of other kids are—I might have gotten a little too cocky. Again, crawl before you walk. It's something all parents should consider. Not saying you should do it—I don't tell other parents how to raise their kids just as I don't want other people tellin' me how to raise mine— but it's worth consideration.

When I got a little older, around age six or seven, it was time for my first shooting lesson. I don't remember the caliber—my dad and I go back and forth on this all the time—but I know it was a revolver. We were standing in front of a tree and he just got behind me, put his hands over my hands, and guided me into the proper grip and stance. He went through the basic technique of aiming and firing and then it was up to me.

As time went on he exposed me to many different guns, their power increasing as I proved myself capable and, more important, respectful of how they should be handled. Shooting wasn't a game. That's not to say we didn't have fun. But I needed to demonstrate both understanding and appreciation for the responsibility he was giving me. This would be an ongoing theme with him as I grew up. He'd give me the responsibility and it was up to

me to get it right or screw it up. And that's exactly what happened when I turned eighteen and he brought me into the Red Jacket mix.

I was working three jobs at the time: a bookkeeping job at a grocery store; hostess, waitress, prep cook, regular cook, and cashier for a local restaurant—I pretty much trained myself to do everything; and then I was also working at Red Jacket on the weekends—gun range, the sales counter, keeping the books, whatever my dad needed. I wasn't sure what I wanted to do with my life yet so I figured I'd just learn and do anything and everything and go from there. And then one day my dad walked into the restaurant and said, "It's time."

I'm just looking at him all funny, like he had a third eye growing in the middle of his forehead, thinking to myself, What are you doing here? I'm not supposed to see you until Friday.

And my manager is standing right beside me, looking at me looking at him, clearly wondering what the heck was going on, same as I was. So my dad repeated himself.

"It's time."

"Time for what?" I asked.

He smiled, but he also gave me one of those "well duh" looks, like I should know exactly what he's talking about. Then he said, "Time for you to take over Red Jacket."

I didn't know how to respond.

"Are you ready?" he asked.

"Sure."

"All right, let's go," he said.

"Like now?"

"Yes, now. Let's go."

My dad isn't the kind of man you keep waiting. Never was, never will be. That applied to family, too.

"Dad, I'm working," I replied, unsure of what else to say.

"No, you're not. Not here." He turned to my manager. "You're the boss?"

"Uh, yes, I'm the boss, sort of," my manager said. "I'm the manager."

"Well, she ain't workin' no more."

As you can probably surmise, my dad isn't the kind of man who takes no for an answer, either. My manager knew that. And if he didn't, he sure figured it out lickety-split.

So that was it. I said good-bye, walked out, and never looked back.

Now, I'm the pink elephant in the room (although I'd much prefer to be associated with a more svelte creature!)—a woman running a business in what is generally seen as a testosterone-heavy industry. And not only am I running the business, but I'm also doing it on television for all to see.

I'm loved. I'm hated.

I'm idolized. I'm vilified.

I get fan mail. I get hate mail.

I've got people telling me I'm pretty. I've got people telling me I'm not pretty enough.

Here I am doing everything in my power to make a

business work in a very tough economy, be a good mom to my kids and a good wife to my husband, and people are chiming in about my looks or my weight or any old thing that doesn't really make a damn bit of difference in the grand scheme of things. That's the one thing that doesn't change: everyone seems to have an opinion and they aren't shy about sharing it. My dad has become the face of the gun industry, and in many ways I have, too. But perhaps the scariest aspect of that truth is that it's not just in this country. *Sons of Guns* has been broadcast around the world. To think that my words and actions might have some effect on what someone on the other side of the world thinks about guns scares the heck out of me. Hopefully, when all is said and done, they see me as a smart woman who is unafraid to stand her ground— someone who can dish it out as well as she can take it.

But for those who know me—I mean *really* know me—this isn't surprising. No news flash. My dad raised me to be like this. Friends would joke that I have a bigger dick than most guys. I know that's not very ladylike or PC—and it certainly isn't true in the anatomical sense—but growing up, my father would tell me, "Stephanie, there is nothing you can't do. You're just as strong as me. You're just as big as me. You're just as powerful as me and you're probably a hell of a lot smarter than me." He pounded those thoughts into my head so that I'd never question it. Never question my place in the world or what I was capable of. As time went on I felt indestructible. Like the only people who could stop me were God and Dad. Some fathers give their kids fancy cars or new clothes or all sorts of material things. My dad gave me strength and conviction. He empowered me. It was the greatest gift I could have ever asked for.

As I got older I wanted to know everything. I wanted to be stronger than everybody. I wanted to be faster than everybody. I wanted to have power and respect. I wanted to be looked at as something bigger than just another girl in the world, someone capable of reaching out and touching people in some way. Never did I think I would come to have the platform that I do now. Again, it's empowering but it's really scary, too.

I mean think about it. Everyone has a job. But how many people have a job that can really change people's character or their true beliefs? Make them stronger and more confident. Make them believe they can do any-

thing. There aren't a whole lot of jobs that come with that perk. And to think, what started out as just a little gun shop in Baton Rouge, Louisiana—just good, God-fearing people trying to earn an honest living—has turned into something so much bigger. People actually care what we think and say and do. And if they don't like it, they're six-gun quick to let us know. But, by the same token, we also receive a ton of encouragement and support. And while I know there's a yin and yang to life—you can't have the good without the bad—I much prefer hearing from the people we help to understand something, or who we've championed in some way without even knowing it, rather than those who simply hate everything about us even though they really don't know us.

I look at it this way: you've got counselors out there, people you go to and ask for certain opinions and, often-times, the folks who went to them aren't happy with the answers they receive. They say things like, "Oh, you're just patronizing me, saying what I need to hear."

Then you've got doctors—God save them—who do amazing work. They fix bodies, put people back to-gether, keep 'em alive, but they don't get to *change* people's hearts. Not what's inside 'em, anyway.

Then you've got the preacher. Now, people love the preacher sure as water is wet but everyone cusses the preacher when they're just a little bit too sad.

And then there's itty-bitty ol' me, Stephanie Hayden. I'm just a regular gal from Louisiana. I like shopping, and

dancing, and a lot of the stuff other girls love. But I also like standing up for what I believe in, and I firmly believe in what this country stands for. I believe in the wars we fight. I believe in the men and women who die for our freedom. Maybe that means I've got a different outlook than most, or maybe it's just because I'm not afraid to say what I feel. But I've been given this incredible forum—everything happens for a reason—and I can't shy away from that. When other people ask me—especially women, some of whom even look up to me, which still freaks me out a bit every now and then—I owe it to them, and myself, to stick to my guns, no pun intended.

This job, this show, my life experiences: I guess they make me a rather unique individual with the opportunity to speak to a lot of different people, to share my experiences with them and find a common ground with many of them, learning and growing from the things they share with me.

But it goes deeper than just the people that come through Red Jacket's door. Much deeper. They don't call it the information age for nothing. We live in a "media now" world. The Internet, Twitter, reality television— you name it. It's out there. If "it" happens, you can see it or read about it. Heck, even if it doesn't happen, someone might say that it has and, before you know it, that story's got legs. Stilts! Like the game of telephone. What starts as an innocent statement or anecdote quickly turns into an encyclopedia volume or maybe even a whole collection

of volumes. That's how quickly it happens. That's why when people ask if I Google or Yahoo search myself, I always just tell 'em I don't have enough time most days to eat lunch, let alone bone up on what I've supposedly been doing or saying, or who's saying what about me. That's not to say I'm not curious. I'd be lying if I said I didn't care about my public perception—that took quite a bit of getting used to—but there comes a point when I have to just accept it and move on. I don't have to agree with it all, of course, but I have to accept the situation for what it is and make the best of it.

Looking back to the moment this crazy ride began, when the reality of being a part of a reality television show actually hit me, I'm not gonna lie. I struggled with it. No matter how much good stuff I read, every negative comment—even the smallest, most inconsequential one—rubbed me raw. I knew how much hard work we had all put in—the blood, sweat, and tears that we had invested over the years, long before the show came about—and it really hurt to read or hear things that were just plain mean for mean's sake. Things that from a business standpoint—from a Red Jacket standpoint—didn't matter a termite's toe. That's what made me think about throwing in the towel, and I've never quit anything in my life. Of course, it was my dad who put it all into perspective, like he always does. Understand, he didn't force me to make a decision about sticking with it or not. He simply asked me why I gave a crap about what everyone else thought regarding things that as I said didn't matter. The

way he put it was like coming face-to-face with a bear when you go out of your tent one night to take a pee. The bear isn't mean or angry or nothing. It's just there, being a bear. Doing what a bear does. It's how you elect to deal with it. Either you accept it for what it is, act accordingly, and move on or you go to pieces and let it tear you apart.

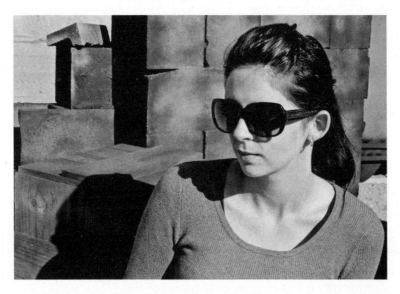

That's when the bell went off. At first I was like, If that's what you're going to focus on—whether I've got a pretty enough smile or if my boobs are in your face or if my butt looks too big in those jeans—why the hell am I bothering with this? But then I looked past the bullshit and embraced the opportunity in front of me: the opportunity to talk to people about their rights, the things they can do, the types of weaponry they can legally own, and the many ways citizens of this country can protect themselves. Those are the important things. The things

that really matter. Being angry or upset by the comments of people that I don't know now and probably never will isn't the way I want to live my life or the belief system I want to raise my children on.

And that's exactly what happened.

The real issues began taking center stage. Our real purpose started sinking in. We were given a chance to change people's mind-sets, especially women. Make them unafraid. Empower them like my father empowered me. And who knows? That might just save someone's life somewhere along the way. That's why I decided it was worth it. So if I needed to continue putting myself out there, be the one who gets beat or spit on—you wanna stone me, go for it—if it helps prove my point and helps get more women around the world prepared and safe, making them feel protected not by someone else but by themselves, how can that not be worth it?

Having said that, there are still times when I wish I could turn it off, if only for a little while. I'll be at the grocery store buying milk and eggs and stuff, thinking about all the usual family things, and maybe I'm not in an on-camera type mood and someone will recognize me from the show and ask me something and I have to be sure to answer with my mind properly engaged, not just say the first thing that comes to mind—which could easily be, "Do you mind, I'm trying to buy my damn groceries." I'm not saying that's the case, I'm just saying. It's tough sometimes.

You hear some celebrities say any press is good press.

That even bad press is good press so long as they're talking about you. First, I'm hardly a celebrity. No matter what people say—and I understand the definition of the word and how it applies to me—I don't see myself in that regard. And I don't ever want to be like that. Even at the risk of hurting the show's popularity, I don't ever want people to say, "Oh, there's that gun girl again." Or, "Look at her, getting herself on-camera for something that has nothing to do with what she does." That's not me. And it never will be. Now, that's not to say I wouldn't try to capitalize on the show's success and the supposed following I've amassed, if the opportunity presented itself to keep empowering women, to empower lawful gun owners and firearms enthusiasts, and law-abiding, God-fearing American citizens who believe in the Constitution of the United States and all it represents.

Please don't misunderstand me. It's not like I'm planning on running for office or anything like that. I'm just saying that if some sort of movement came about and I was asked to take part in some way, above and beyond *Sons of Guns*, so long as I'm not compromising myself, my ideals, or my beliefs in what some might perceive as a grab for fame, I'd be a fool not to consider it. Bottom line: if a camera is going to be on me, or if a microphone is going to be in my face, I want it to be for all the right reasons.

That's one of the things that drives me crazy about "celebrities," especially the folks that aren't really honest to goodness celebrities but still receive plenty of at-

tention. There are so many people out there who could stand up and do something real, something truly huge, because the world is watching them and the general public has shown time and time again that they'd follow every move they made. And yet they don't bother. Either they don't care or they really have nothing of value to say. It's sad. So many amazing so-called role models out there with the means to reach people and so few of them really take the time to do so.

Then there's the flip side of celebrity and being in the public eye—the dangers it exposes you to. As it is, I'm involved in what some would refer to as a controversial industry. I personally don't see it that way; guns are part of the American culture. They helped build this country. But there are those out there who despise guns. Hate them with every fiber of their being. And here at Red Jacket we don't just make guns, we make *machine guns*. We make silencers. We work with explosives and explosive devices. So you can probably imagine that there are folks out there who not only disagree with our chosen profession, but they also disagree with our very ideology.

Now, I've never had a stalker—you'd have to be pretty dumb to stalk a woman who is well known for carrying a gun that she knows how to use—and I hope I never do. But still, these are crazy times in which we're living and, sadly, the unthinkable does happen every now and again.

Look at Chris Kyle. Incredible man, American hero, spent his entire life defending our country. He was a father, a husband, a philanthropist—just a truly amazing

human being. And he got taken out by a *friend*. So I'd be lying if I said I didn't have any fears about some of the people out there who disagree with what we do and what we stand for so vehemently that they might be willing to do something horrific just to shut me up.

But that doesn't just apply to me or Kris or my dad or the rest of the guys at Red Jacket. It holds true for everyone in the firearms industry. In current times tensions are sky-high around the world. Just because 9/11 was more than a decade ago and we're not in the middle of massive

troops movements to the Middle East or anywhere else, we're still at war. Americans wearing the uniform, with the stars and stripes sewn on their fatigues, are putting themselves in harm's way every second of every day, and way too many of them aren't coming back. Those are the known scenarios. People who have trained to willingly put themselves in harm's way. Now throw in the attention that comes with being on a reality television show—a very popular reality TV show, no less—and the stakes are raised. It's something Kris and I talk about quite often: staying true to who we are and the business we're in regardless of what others may feel about us.

Speaking of Kris, while I can't credit the show for bringing him into my life—our history goes way back, long before *Sons of Guns* was even a figment in anyone's imagination—I know without a shadow of a doubt that the show has played a major role in strengthening our relationship into an unbreakable bond, one that defies description. Take whatever metal you think is the strongest in the world—in the universe—and quadruple it. I know that sounds corny but it's true. I am the luckiest woman in the world, blessed beyond blessed. Respect, affection, friendship, understanding, safety, security—I only wish every woman out there could find a man who makes her feel the way Kris makes me feel. He's my other puzzle piece. We're a perfect fit. I've told him time and time again that there is no other guy out there more perfect for me than he is.

And he always comes back with, "Oh, I'm not perfect."

So I laugh and nod, saying, "Trust me. I know you're not perfect. I just said you're perfect *for me*."

If you've seen me on the show you know I have my moments. Don't we all? But as far as a relationship goes, I needed a man who was going to push back a little bit. Maybe even more than a little bit. A strong man. A man with conviction. A man who would stand up for what he believes in, even if it's not the popular sentiment. I also need a man who believes in something greater than the here and now. Something bigger than us. A man who knows what the world needs and wants to be a part of that. And above all else, I need a man who believes in God. Kris checks all those boxes and more. I'm so involved in what I see as my mission and I couldn't be with anyone who wasn't as strong or as determined as I am in that regard. But not only does he support me; he helps me elevate that cause because it's in his heart, too.

The funny thing is Kris wasn't even a "gun guy" when we first met. In fact, when he started at Red Jacket he didn't really know guns. I mean sure he knew the basics, but it wasn't like he was a gunsmith or a gun expert or anything like that. And for the record, I wasn't looking to be with a gun guy. Being heavy into guns wasn't a part of my ideal dating criteria. More than anything I needed someone with an understanding of the basic reality of life, of what this world really is, not the TV perception or the day-to-day scratch-the-surface idea. I needed to be with someone who had a deeper sense of not only who he is but a comprehension of the world around him.

The sad truth is people don't talk to one another anymore. When you walk down the street, people don't speak. They've got their faces buried in their phones or their iPads or their BlackBerries. You hear so much talk about the zombies and zombie invasions. News flash: *we are the zombies.*

Kris understands this. He and I see the world the same way, almost like we're looking at it through the same pair of eyes. We've got independent thoughts and ideas, but we truly come to many of the same conclusions. We both want to speak to people and bring them back to a moral, good, God-fearing way of life. The foundation this country was built on. Somewhere along the way we, as a people, got away from that. I mean you don't have to have laws to tell you not to do certain things. We all have a moral compass. We know what's right and wrong. When did we stop using that compass? Did the societal fog get so thick that we simply lost our way?

Nowadays, too many people don't care. They've been told it's cooler just to shrug their shoulders and not give a damn. Be noncommittal. It may work for Switzerland but it doesn't make any sense to me. So many things stopped making sense because so many people stopped caring. It's moving this great nation of ours—and the world, for that matter—toward a very scary place, a precipice we may not be able to get down from. Think about it: if you're so afraid of saying something because you don't want to hurt someone's feelings then you're not living in a free country. If you have to be so PC that you can't say anything

that you believe in because you might ruffle the feathers or crease the brow of one out of a million people's feelings and you're more worried about numbers and polling and percentage disagreements and all that, *you are not free.* Welcome to encampment. Welcome to Big Brother. That's not this country. That's not where we need to be headed. But we better get it back on track before we go off the deep end and can't save it.

But I need to be clear on something. Stating my feelings and sharing my thoughts doesn't mean preaching to people. And I'm certainly not trying to force anyone to my side of the table. However, I do want to spark the conversation, make them realize there's no reason we can't bring about the change we need. If we band together, we can accomplish anything. The states control this country. People forget that. But I didn't forget it. Kris didn't forget it. My dad certainly didn't forget it. And if it takes us to remind people, then so be it. That's what we'll do.

And it seems like the movement is growing. In recent years we've seen more sheriffs and state governments stand up and say, "You know what, Mr. Federal Government? I don't care what you say. I run my state and this is what it says. This is what my constituents are telling me. So I don't really care what your law is because mine supersedes it." It's sad that it's come to that but it's just like bullying in some elementary or junior high or high school. It's the same freakin' thing, only on a bigger level. At some point, you have to stand up and say enough is enough.

That's why I think it's funny in a lot of ways that my dad is being seen as the face of this movement. He's just a humble guy, even though the show makes him out to be something completely different. Although, at times, he is "that guy." I mean the camera doesn't lie.

But for those who really know him, he's just a simple guy, happiest when he's got kids and dogs and friends around him, barbecuing and sharing stories, living a simple existence. Then the show came along and really put Red Jacket on the map. But it also put him on the map in a major way—put him in the center of the cross-hairs, too. He became the face of the gun movement in America. And rather than duck out of the way, he stood tall and embraced it for what it was and just talks it like he walks it. I can't begin to tell you how proud I am of him and what he's done, and the positive effect he's had on so many lives. He'll never talk about it. He's way too humble for that. But what daughter doesn't want to talk up her dad?

To this day that's the biggest misconception about him. The general public sees him only as the "machine gun guy" and expects him to be this larger-than-life, big, cocky redneck asshole who's got a gun (or ten!) within easy reach, no matter where he's at. And that's just not him. Not any of us. I guess we're all just a little too Christian for that. Besides, any man who has to stand on the pedestal and puff out and beat his chest to show he's in charge ain't in charge.

But you have to understand, you're gonna see some of

his in-your-face, my-way-or-the-highway moments. Heck, maybe more than some. After all, the editors have hours and hours and *hours* of footage to go through and they can't just show the boys drilling and welding and building guns.

However, it seems the only channel turning people are doing these days is *to us*. That's not to say I didn't think we'd be worth watching, or that the kind of things we do on a daily basis aren't cool but, c'mon, I'd be lying if I said the general acceptance and, taking it a step further, fanfare we've received were beyond my realm of understanding. And when it's all said and done, I'm truly flattered that people continue to care about us, about the work we do, and about the products we make.

Sure, people tune in for the characters, the folks they've come to know, to see what can of worms they'll open next or goofy prank they'll play on one another, or what Willism my dad spews next. Whatever value they find in the show, be it what we do, how we do it, or the way we do it together, I'm thankful for all of it. And I hope it continues, which is something that especially when this craziness started I never thought I'd be saying. But just as people have come to love us and seem to genuinely care about us, I can tell you we care about them, too. There are folks out there who are depending on us. I'm not talking about the guns we build for them, private citizens or specialized military weapons. I'm talking about the people who truly believe in the things we're about, the core values of Red Jacket, and some of the topics that get

discussed, even if we're barely scratching the surface.

Naturally, I also have moments when I wish I could pull a Dorothy and click my heels and make all the cameras and producers go away. Take getting into an argument with someone. It's bad enough when it just happens. But it's like getting bit by a pit bull on your butt on a cold day when you know a ton of people will be watching it a few months later. And if that isn't bad enough, you wonder how many people will be talking about that argument and posting comments on the Internet after the fact, so that the argument might flare all over again because someone read something and it made them think about it again, or just think about the situation differently. That's the downside of the show—of any reality show. It's out there forever.

Take the "situation" that happened when I took some photos on one of Jesse James's bikes. It was just a harmless photo shoot. I like hot bikes and I like getting photos taken of me on hot bikes. No harm, no foul. But someone sees me on a bike that isn't my husband's, with a guy that isn't my husband, and maybe some of the photos are a little too sexy for their liking, or strike them as being too showy in some way, and then it's like the skies have opened and the rain gods are just pouring buckets of criticism at Kris for allowing me to take the photos in the first place, or blasting him for not getting in Jesse's face, or just a whole slew of "you should do this's" and "you should do that's." On the one hand it's flattering that so many people care about you and are interested in

the little things you do during the day, and on the other hand it's scary as all hell knowing that the little things you do during the day are being monitored and, ultimately, commented on to the point that every possible angle, scenario, and opinion is covered, regardless of how I may feel about the situation.

In fact that's not just scary; it's terrifying.

People still look at me like I did something wrong in that scenario. And they look at Kris like he did something wrong. And according to what I've been told, they think Jesse did something wrong. But the truth is nobody did anything wrong. They weren't here. They only saw the way it played out on TV. Kris knew I was going to take pictures on Jesse's bike. Jesse knew I was going to take pictures on his bike. I just never planned on taking pictures on Jesse's bike with Jesse. One small thing leads to something bigger and that leads to something bigger still. I get it. It's the nature of the beast. But in the grand scheme of things, Kris, me, and my dad—even though he won't readily admit it as quickly as I will—are glad to have that beast in our backyard. It's good for Louisiana, it's good for Baton Rouge, and it's good for Red Jacket.

It was because of the show that I realized the importance of taking time away from work—not a vacation, mind you, just a little time—to unwind, if for no other reason than to appreciate life and the people I care about.

Kris and I will go and sit in the most nature-filled place we can find, no matter where we are. Don't get me wrong. We love to take our personal time and shoot guns and do

the tactical training thing, or spend a little time in the city and do the urban thing. But when it comes to escaping, there's nothing better than just getting away from it all and marveling at the majesty of God's creation.

One of the things I really enjoy doing is free-scale mountain climbing and I finally got Kris interested in it. On one trip, I made him trek up a frozen river leading to a climb up a frozen waterfall in this amazing canyon. Throughout it all he was cussing me up a storm, but finally, when we got to the top and he looked out and took it all in, it was simply breathtaking. That's when he just gave a big sigh and was, "Oh my God."

I smiled. "Yeah, that's about the only thing you can use to describe that."

The light was hitting the waterfall just right and it was pink and green and blue and yellow and red—a complete rainbow inside the ice. And we're talkin' about a twenty-foot cascading waterfall that was just frozen in place, like Mr. Freeze just went *zap*, and you're standing on this frozen river that's barely four inches thick with the water rushing under you, and you're just filling your brain with images like it's a memory card that you're stuffing full of the most incredible photos imaginable. And every time you turn your head, even just a little, you see a different image, different colors reflecting from the rocks behind it, the different minerals, the frozen clearness of the ice, the white. I don't know that there's a word that does it justice.

But it doesn't have to be a major trip, some crazy odyssey to the other side of the country or the world. It can be

somewhere near the house, anything that's natural and pretty where we can just sit and look and appreciate. Or we'll go to New Orleans and sit by the river and drink a cup of coffee—just as long as we're not looking at metal and plastic.

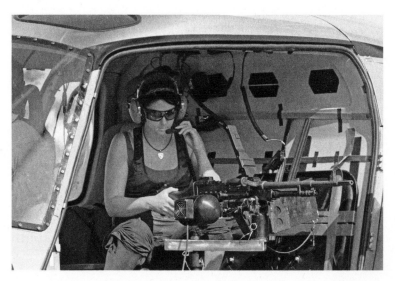

And then there are my two kids whose names I never share. Not that I think there's anything wrong with the show but it's something I want to shield them from for the time being. They know about it, know what it is, and they watch it, but the less they're a part of it, the better. However, I never conceal anything about it from them. In fact, I don't conceal much of anything. I talk to them like they're adults, and when they ask me a question I don't sugarcoat it. I tell them the truth. Even if it's hard for me, even if it's something that for all intents and purposes isn't the most kid-appropriate information.

For example, my six-year-old probably doesn't need to know why a trollopy-looking woman wearing fishnet stockings standing on a corner is leaning over into the window of a car. But I would choose to tell her, explaining it as delicately but honestly as possible, because I want her to know that that's not the life she ever wants to be in. I'd tell her that's what might happen if she doesn't do well in school and doesn't try hard at everything she does, and doesn't have ambitions. You end up doing nasty things that you won't be happy about. Understand that I wouldn't get into gross details or the specifics of the "profession." There'd be no need. But I'd get the point across just the same.

And so far, this approach seems to be working. Both of my kids make good grades and can hold a conversation with you as if they were thirty, but a light and fun and friendly conversation, not the kind of smartass, condescending chats some kids seem to gravitate toward. They're both well-spoken and very respectful and I hope it stays that way.

In terms of personality, my son's a little quieter than his sister. He's always been that way. Early on, he had a rough time between me and his father, who he would try to get away from. His dad—not Kris—wasn't so great, but to his credit he's become a much better person. I know it's something he's been working on and it shows. Look, we all have our flaws and some seem to explode to crazy proportions when children are involved and relationships with the parents are going sour. But that's why I think

it's important to treat children as little adults. Granted, I know it's a different way of raising kids, one that isn't for everyone, but it's working for me thus far and I think they're going to be better off because of it.

And that way of treating them cycles back to how I've explained, and how they view, the show. They don't understand the concept of a TV star because Kris and I and my dad have never been fans of any particular celebrity type, and we certainly don't carry ourselves that way. It's a job. That's all it is. A job that comes with some pretty cool perks. Although I have to admit that growing up I always wanted to be an actor. So, in a way, I'm getting to live my dream.

Plus, there are so many other things I'm working on: a concealed carry clothing line for women—clothing that is both functional and comfortable that actually looks good, you know, cute for regular chicks, not simply appropriate for female cops and security professionals; training courses (Kris and I want to travel across the country, train with all the major badasses in all the various disciplines of weaponry, CQB, personal protection, you name it, and then be able to teach the skills we've learned); and our continued and increasing efforts to make a positive difference in society. The show and the platform it provides bring new possibilities my way—and our way—on a daily basis. It's a wild ride that with any luck will continue!

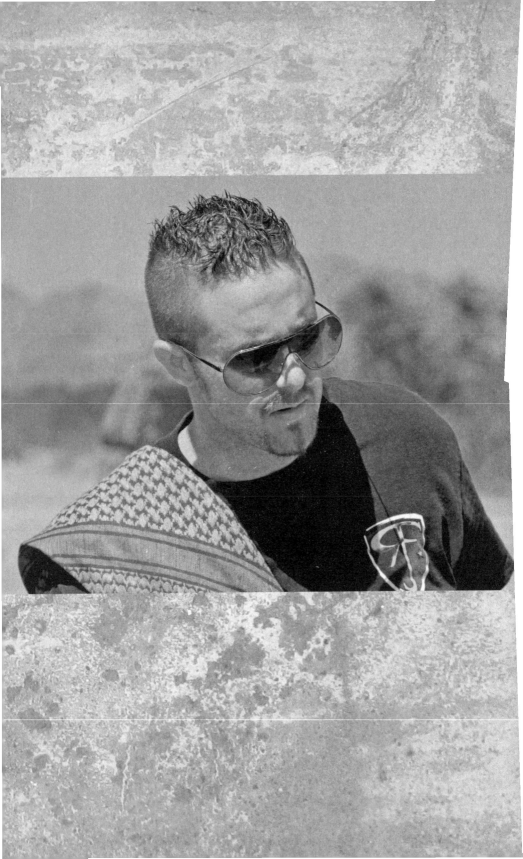

The problem is not the availability of guns,
it is the availability of morons.
—ANTONIO MELONI

Kris Ford:
The Heir Apparent?

ris, Kris, Kris. Where do I even begin about Kris? That boy is like a riddle, wrapped in a mystery, inside an enigma. Clear enough for ya? No, well good, 'cause I still haven't figured that cat out yet myself. But I can say I love him like a son, even though he's like an unscratchable itch to me half the time.

Do our personalities clash? Hell yeah, they do. More than I care to admit. If you watch the show then you know what I'm saying is the gospel. But when any man

in charge of his own destiny goes nose to nose on a daily basis with a like-minded individual that's bound to happen. If it don't, then one of those folks ain't being true to himself. And I can tell you sure as a skunk has stunk that Kris always stays true to who he is, no matter the situation. If I didn't admire and respect him for that, you think I would have let him get near my little girl, let alone put a ring on her finger? Hell to the no. Granted, Stephanie's her own woman and her decisions are hers and hers alone but that's a horse of a different color and I ain't going there.

Speaking of horses, more specifically donkeys, if you thought asses were stubborn, Kris would give the world's most pig-headed mule a run for its money. I say that with praise. If that boy gets something in his head, ain't nothing going to shake it loose. Fighter-jet missile radar lock could benefit from his tenacity. And when it comes to Red Jacket I'd probably quit before he would.

That's what makes his story all the more amazing. When he first came to Red Jacket he didn't know his nose from his toes about guns. Oh, sure, he knew about guns on a general level but not in the sense that you'd expect a gunsmith to know 'em. And as you well know, with machine guns, grenade launchers, and—his personal favorite—cannons coming through our door on a regular basis, we're a hell of a lot more than just a neighborhood gunsmith.

But now? Forget about it. He knows as much as any armorer you can drum up. Shoot, you could blindfold him

and throw him into the swamp with a sack full of miscellaneous gun parts and before long he'll crawl out of that quagmire with something that looks as good as it works. Heck, knowing Kris, he'd probably even call it a cannon!

Before Kris joined the team it was just Steph and me, undermanned and then some. I was on the lookout for quality people to bring into the mix—there's always more work to be done than there are hands to do it—and they didn't need to be weaponry experts, either, just folks who were willing to give me 110 percent whenever they set foot inside the shop. But that's how it's always been with me; show me someone willing to work and I'll give that someone a job. It's that simple.

Anyway, Stephanie bumped into Kris at a party. They knew each other from way back. Kris was friendly with the father of her two kids, and since he was looking for a steady gig—he had been doing construction work and selling music on and off—she told him to come in and give it a go. So in he walked the next day and we got right down to brass tacks.

"What are you used to making?" I asked.

"Sixteen dollars an hour, but I don't know anything about guns," he replied.

"I'm not worried about that. There's plenty of work to do that's got nothing to do with anything that shoots. But you won't be making sixteen dollars an hour. You won't even make half that. Rate's seven dollars per, but we take care of each other. We're a family."

"Yeah, I've heard that before," he said.

"Not from me you haven't."

"All right, I'll take you at your word," he said and that was that.

He started right then and there. Sandblasting guns, sweeping the floor, putting stuff away, although his job description was more about taking care of me.

"Better learn to read my mind," I told him. "You're gonna hear me and know what I want done *before* I ask you to do it. If you don't, we'll have issues. Your real job is to keep me happy. Keep this big, dumb marine happy."

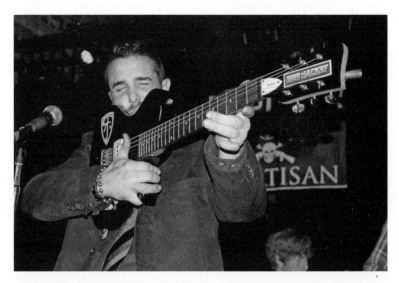

I knew from the jump he was seriously wondering what the hell he had gotten himself into. You could see it in his eyes. Even though his father, brother, and sister were, ironically, in the gun biz—Ford's Firearms—Kris didn't consider himself a gun guy and never took an active role in the family business. Hand the boy a guitar and he could make it weep. Hand him a gun and he'd conjure up a way to turn it into a musical instrument.

"I don't know what any of this stuff is, much less where it goes," he'd bleat while looking over the miscellaneous parts-strewn benches where I'd been working.

"No worries," I'd say. "Just tidy the place up and if you find something on the floor that looks like a gun part, pick it the hell up."

At some point during that first week Kris went to Stephanie seeking advice. More than just worried about keeping his job, which, much to my surprise he actually liked, he was worried about screwing up one or more of the guns. But she put him at ease by giving him my three rules, three rules that every employee who comes to work for Red Jacket learns within days (or hours) of hiring on. They are:

1. Always say, "Yes, sir."
2. Be expected to do all sorts of things, not just work on guns.
3. Whenever possible, run.

Do those things and I promise you'll keep your job. Whenever new hires join the team and I hear someone giving 'em the rules, I listen for their response. If they giggle at any of 'em, I know they won't last very long. You don't have to know diddly-squat about the work we do. Don't get me wrong; it helps. But if you don't, we can teach you that stuff. Heck, I could teach a monkey to break down and reassemble an AK if I really wanted to, but I'm sure PETA would take issue with that.

I'm more about work ethic and manners. If you don't already have those when you come through my door, chances are the ship's already sailed and it won't be returning to port anytime soon. At least not *my* port.

But as confused as Kris may have been initially, he has a solid understanding of all things mechanical. So it wasn't long before he and I were assembling the ordered guns together, step by step, part by part. Then, on Friday, he and Stephanie would ship them out. On Monday we'd start the process anew.

Every now and then I'd give him a little spiff of cash, enough to make rent or whatever, just to honor that initial promise I made to him about being taken care of. It wasn't a lot, of course, although it might have been more than he was supposed to get according to the hourly wage he'd agreed to. Maybe even more than the company could afford at the time. But that didn't matter. Family isn't about contracts and agreements. At least it shouldn't be. Mine certainly ain't.

Eventually Kris quit any other work he'd been doing on the side, moved out of his apartment, and moved into the shop. He even sold Stephanie his car. She needed dependable transportation what with two kids and all and I guess he didn't mind relying on his own two Fred Astaires to get him where he needed to go. On the upside, he was able to eliminate having an electric bill and a water bill and I sure as hell didn't mind having a full-time "security guard" on the premises. I know it was a little invasive for him when we first started filming—his workplace and

his home now had people crawling around it nearly 24/7, toting cameras no less—but if it had to be anyone I'm glad it was Kris.

As you can tell from the show, he's the most outgoing and upbeat person you could ever hope to meet. Take a cloudy day, add Kris Adam Ford into the mix, and you've got instant sunshine. Might sound sappy but it's true. Upbeat and then some, which seems to fit that cigar-band tattoo he's got on his arm: KEEP MOVIN'. He doesn't just smoke those things; he lives their message.

Heck, stick that boy in a room with a dozen complete strangers and in an hour he'd have twelve new friends. Good friends, too. I bet they'd help him move a body if he asked. Why do you think he's the one they look to when they need a big, over-the-top reaction after we shoot something big or blow something up? But that's not just for the cameras or posterity's sake; that's just Kris being Kris.

That's why it didn't surprise me that he went out of his way to get to know the crew that first season. He'd go to their hotel, hang out with them, drink with them, basically get to know them beyond the confines of Red Jacket and the show. So that first year, if Kris looked truly comfortable on-camera whereas the rest of us jackasses looked like blind mice struggling mightily to find our way, now you know why.

Once Kris got his sea legs regarding the basics of firearm internals and putting our guns together, even though he was far from Sam Colt, I was impressed by his willingness to jump into the fire no matter how intense the blaze. And since he lived on site, he would always declare himself on call.

"Dude, I don't know much about this," he'd say with a puzzled look on his face, usually holding up some of the parts that needed to be pieced together. "But I work hard and I'm a fast learner."

It didn't matter if it was 11:00 PM, 2:00 AM, 6:00 AM. Just as long as he got a few hours of shut-eye he never wavered when it came to putting himself out there to bring a project to completion, including those projects he was clueless about going in to and was forced to learn along the way.

But again, that didn't surprise me. He attacks life, although he tends to do it with a smile on his face. And it's infectious, too. I've chewed out his ass many a time only to wind up smiling at him or hugging him a few breaths later. It's no wonder they say he's the glue that binds us all together.

Crazy glue. And yes I mean crazy not Krazy.

It's all a part of his outlook. His master plan. Kris told me a story about how, when he was very young, he promised his dad he was going to be famous when he got older.

Rather than muffle that boast, his father nurtured it: "Well son, you had better learn to sign your name really fast with solid, legible letters because every famous person needs a good autograph."

Funny how things come about. Kris has been singing since he was three and writing songs since he was nine. Growing up he figured drama or music—acting, dancing, singing, composing, musical stage, something in the expressive arts—would be the path he'd follow to stardom. Never in a million years did he think guns would put his mug in millions of households the world over.

Beyond his talent, the kid's got smarts, too. On top of the music scholarship he had for the University of Miami, he also had an academic scholarship to Nicholls State University in Thibodaux, Louisiana. Unfortunately, both of those free rides went unclaimed. Kris used to party like a rock star without actually *being* a rock star—a rather dubious methodology that resulted in an uninspiring existence; he floated around from place to place, living on other people's couches, working odd jobs here and there just to make enough money to eat. Yet while that doesn't sound like a "proper" road to success, the life experiences he amassed along the way were invaluable, especially to a man with a vision of becoming a household name singer/

songwriter. Even I know that you can't write and sing about life and all its hills and valleys if you haven't seen fit to traverse 'em from time to time.

Another important aspect of Kris's life that shaped how he views the world today concerns his older brother, Kyle. Now those two weren't exactly bosom buddies. In fact, I think Kris would say he was downright rotten to his elder kin for quite a while. Those boys were the definition of oil and water. Kyle was a cop for nine years and also worked in a prison, doing everything to honor the badge, whereas Kris was living on the other side of the law and order equation. If you put the pair in a room, chances are neither would have come out alive.

But when Kris began working at RJF, something changed between them. Kyle praised Kris for finally sticking with something, told him he was proud of him for turning his life around. I wasn't there, but knowing Kris the way I do, it likely melted his heart. Sadly, no sooner did the two of them bury the hatchet than Kyle's Guillain-Barré syndrome flared up.

For those of you without a PhD, Guillain-Barré syndrome is a horrible disease, an unpredictable nervous system disorder that doctors commonly refer to as GBS. It's rare, too; only about one to two cases per hundred thousand people. First, it paralyzes you to the point you can't feel your nerve endings and then it starts to shred them because your immune system goes haywire trying to figure out what's wrong. Eventually, it starts shutting down

your nervous system completely and then it's just a matter of time before your family is making final arrangements.

Now Kyle is one tough customer. He's been hit by cars, crashed motorcycles, and gotten into more fights than most pro boxers ever do. But GBS was a very different opponent and it quickly brought Kyle to his knees. I'm talkin' death's door. ICU for nine days, his body completely shut down save for his heart and respiration.

We were in the midst of filming the bazooka episode and every day, as soon as we wrapped, Kris would hightail it over to the hospital and spend the night crying and praying over his brother. It nearly broke him to see such a strong guy reduced to a shell of his former self.

But I said nearly. Kris didn't give up on Kyle and Kyle didn't give up on life. I'd like to think the strength of the two of them together is what beat GBS. Because Kyle pulled through, and if you remember seeing him on that episode—it was a fleeting moment, barely thirty seconds or so—he and Kris shared a smile, the first time they'd done so in a decade.

Now, we mess around with some pretty powerful stuff on our show but I'll bet a case of Steyr AUGs that that smile was the most powerful thing any of our editors have ever handled. And boy did they do it justice.

Seeing Kris in that context told me volumes about him, and I knew it was only a matter of time before he and Stephanie would find each other. Remember, they had known each other for a while and there was never

anything between them except maybe a bag of chips and a beer. But knowing each of them like I do—being the one on the outside of the glass looking in, in addition to being inside the tank with them, too—I could see the writing on the wall long before anyone scribbled it there. They just needed to figure it out for themselves.

At the time Stephanie was with a guy I didn't like— major understatement but I'll leave it at that—and she finally got to the point where she didn't like him, either. Kris wasn't with anybody serious, just having fun doing his thing. So they just kind of danced around the inevitable for a while, like two prizefighters circling the ring. You know they're gonna come together eventually. Everybody watching does, too. You just don't know when. But you know that when they do, something special's gonna happen.

Eventually they gave in to temptation and started dating, and before long they were inseparable. Having the same thoughts, finishing each other's sentences. It was sickening in a cutesy-cheesy kind of way but I was genuinely happy for both of them. You find someone in this world you truly connect with, beyond everything you think about love and what it entails, and it's an incredibly special thing.

After a few months of that I decided to step in and light a fire under that boy's ass. So I took him aside and told him he needed to move in with my daughter. Get the hell outta the shop. He was there enough. Didn't need

to be living there anymore. To his credit, he flipped the script on me right quick.

"If I am going to move in with your daughter and help raise her kids, I'm not gonna be like the rest of these assholes along the way."

"What are you trying to say, Kris?" I replied.

He pinned me in this solemn stare and got all matter-of-fact. "Look, Will, I want to marry your daughter."

"Are you sure?"

"Pretty sure."

"You know she's an asshole, right?" I chided.

"Yeah, but you're an asshole, too, and I can deal with you," he fired back. "I think I can handle her."

The boy had my blessing long before he asked but I was impressed just the same.

"Okay, then. Glad to have you in the family."

Then things got fun.

"I want to do it while we're in Vegas," he said. "Whaddya think?"

We were scheduled to fly to Las Vegas for a seminar with the guys at Rifle Dynamics to teach them how to build our guns. The timing couldn't have been more perfect, like it was meant to be. But seeing an opportunity to surprise the two of them, which doesn't happen all that often, no way was I gonna let it pass.

"Sorry Kris, we're not gonna have the time," I said.

As I expected, it was water off a duck's back. "Okay, no problem," he said. "Maybe we'll do it in Arizona after we

leave. Steph and I are going to drive to Colorado just to see the sights and enjoy."

That mind-set played into my plan perfectly, because it meant he'd have the ring on him the whole time. No chance would he leave it somewhere to risk losing it or, worse, Stephanie finding it.

Once we got to Vegas, I made up some bullshit excuse about going to the courthouse to meet the mayor. I gave Kris a look before we headed over and told him he needed to tidy himself up, wash his face or something, 'cause you can't meet a man of the mayor's importance looking like you just changed the oil in your pickup.

So Kris cleaned himself up and I nearly broke a rib trying to keep myself from laughing about what was in the works. But when we arrived at the courthouse and a guy came over and handed Kris limousine tickets and some other stuff, this freaked-out look came over Kris's face and I knew the gig was up.

"I'm about to get married, aren't I?"

"You can back out of this anytime you want," I said with a smarmy smile. "Car's still running."

"No, I'm good," he said, even though I could hear his heart thumping away inside his chest and I knew he was on the verge of passing out.

After getting their marriage licenses, we headed over to the Little White Wedding Chapel and had a quaint and beautiful ceremony. I wondered if they'd want an Elvis impersonator to preside considering Kris's musical back-

ground and affinity for the King but they nixed that idea quick and went with a standard preacher who did a fine job. After the service, a friend of mine with the CIA gave them the key to a two-thousand-dollar suite at the Cosmopolitan and that was that.

Not long after their union was made public, someone aware of my Native American ancestry reached out to them via the Internet, inquiring about whether or not they'd like to have a true Choctaw wedding. I'm pretty sure they're gonna go for it.

But while there are lots of stories I can tell you about Kris, lots of things I can say to give you insight into who he is, one of my favorite Kris tales centers around his dog, Grover.

About a year before Kris started working at Red Jacket, one of Stephanie's friends had a dog that gave birth to a litter of puppies. Stephanie, merely a friend of Kris's at the time, was going over to look at the pups with her daughter and asked Kris if he wanted one. He said yes. When they got to the house, it was Stephanie's daughter who picked the little fella out. A year later Kris is providing for and helping to raise that little girl. If that don't get you right smack in the heart and make you wonder about this crazy world of ours, about fate and destiny and all that, nothing will.

Today, in addition to being a co-owner of Red Jacket—I gave him 5 percent of the pie because if anyone deserved it, he did—Kris and Stephanie are cooking up some exciting new reality show ideas involving the two of them

undertaking all manner of tactical training around the country, and perhaps the world. Maybe they could get Kid Rock to do the intro music and call it *American Bad-asses*.

Speaking of the Detroit rocker, far and beyond RJF and gun stuff, I know Kris has his heart and mind set on tackling the one itch he hasn't yet really tried to scratch—a career in music.

Would I be sad to see him go? Does a frog shit in the swamp? But would I buy his album? Hell no. I'd buy a case!

Banning guns to reduce crime is like trying to reduce drunk
driving by making it tougher for sober people to own cars.

—UNKNOWN

Will's Boys:
The Red Jacket Crew

As y'all know by now Red Jacket ain't a one-man op-
eration. Far from it. Without my family I'd be just
another gunsmith carving on the wood and welding
on the metal of projects you probably wouldn't care to
hear about, let alone watch on the tube each week. My
boys—my tribe—helped me take Red Jacket to a whole
new level. I've already introduced you to Stephanie and
Kris. It's time you met the others, not all of whom appear
on the show.

JOE MEAUX

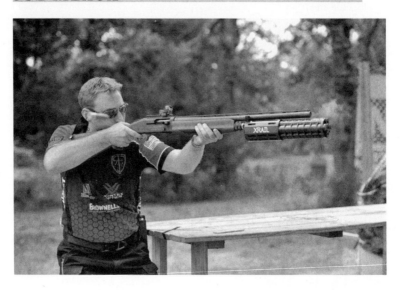

Just when you thought all the Renaissance men were gone, Mojo surfaces. A Baton Rouge native and LSU grad, Joe—Mojo as we prefer to call him—taught at a local high school for a decade and some change before leaving to work at Red Jacket full time. While his official title is chief operations officer, Mojo's true job description extends well beyond the typical duties of a COO. For one, he *is* the development department. When a client approaches us with a project, especially something that's (way) off the beaten path, Mojo is the one we turn to to see if it can actually be done—and be done safely. Granted, there are times when we disagree. Usually it's me who takes the gig after Joe warns us not to, although in the case of the Type 99 20mm Auto Cannon off a Japanese Zero ("Kamikaze Cannon"), I passed on the project

due to numerous safety concerns and Joe decided to give it a whirl without me knowing it.

Joe had an interest in mechanics and firearms long before he came to Red Jacket. Now, instead of tinkering with stuff in his garage—I'm sure he's got a plethora of secret projects at home in various stages of development— he's got a full machine shop at his beck and call and more than a few minions ready and willing to assist him.

Put a weapon—any weapon—in his hand and Mojo is a kick-ass marksman, competing in a variety of shooting events whenever he finds the time. More than a few of Louisiana's feral hogs learned the hard way that when you're in Mojo's sights, you're meat!

Between his love of vintage cars, his enthusiasm for kites (Joe owns MeauxJo Kites, specializing in large, exotic, and dueling kites), and the many hours he spends helping RJF get to the next level you would think there wouldn't be anything left in his tank. Not to worry, Joe always has some fuel in reserve for quality time with his family. If nothing else his beard should have its own Facebook page.

CHARLIE WATSON

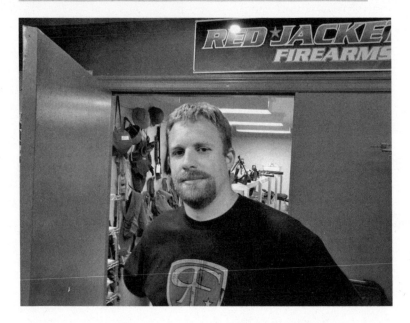

Another local boy, Charlie did the "school thang" at Louisiana Tech U, getting his degree in animal biology, before securing his master's in natural science from LSU. He's another "have wrench, will travel" type of guy and is invaluable to RJF in the capacity of a technical troubleshooter. Although, like everyone else, he'll work on anything you drop on his bench. But Charlie's passion for weaponry goes well beyond the basics. His incredible knowledge of physics combined with an expertise in the science of weaponry landed him the esteemed position of forensics scientist for the state of Louisiana. If you've ever seen *CSI*, that'll give you some understanding of what Charlie does for his "day job," with his area

of specialty being anything firearm related. So to all you would-be Louisiana criminals, if the crime you're thinking of committing involves a gun, you'd be smart to nix that thought right quick or else Charlie's gonna nail your ass!

GLENN FLEMING

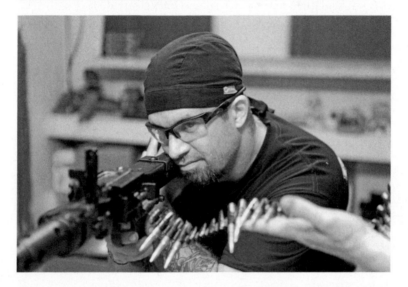

Flem knows so much about weapons and the way they work he could forget half of what he knows and still know more than the most acclaimed gun builders in the game. An air force brat, Flem moved from base to base as a child. He grew up with a solid understanding and great appreciation for guns, but it wasn't until his own military service—air force—that he began receiving serious hands-on firearms training. As you can imagine, he excelled. Flem ultimately became a staff

sergeant in the Twentieth Special Operations Squadron (20 SOS) and did multiple tours in Iraq and Afghanistan. He also served his country proudly in Bosnia and Africa. When his time in the service was over, Flem continued his passion for weaponry, collecting all sorts of firearms with an emphasis on German models. He joined RJF in 2010, and as you can see by his talents on the show, there ain't nothin' he can't build, fix, or build and fix. As such, if it's got a firing pin and throws lead, Flem was involved in a major way. Unfortunately for us, Flem decided it was time to start frying his own oysters and put out his own shingle. While I'll certainly miss working with someone I have come to know and respect, I understand a man has got to do what he thinks is best for himself and his family and I wish him well with all his endeavors. And if it don't work out for him, he can come on back and we'll discuss his old job—although I might have to dock him a few bucks an hour in the beginning!

CHRISTOPHER MICHAEL "MIKEY" WALLACE

Mikey is like the new version of me. I'm passing on everything I've learned over the years. Well, almost everything. Gotta keep a few secrets up my sleeve. AKs are definitely his wheelhouse. If you need something done on a Kalashnikov, he's the one to see. Of course, even if it ain't one of Mikhail's creations, if it chambers and fires a round he can handle it. But to know all you need to about Mikey, just consider his daily commute. From his home in Covington to the shop in Baton Rouge you're talkin' seventy miles, about an hour and a half each way. If that ain't dedication I don't know what is.

REBECCA RAMSEY

When I first met Rebecca I was out in the vestibule just off the shop, straddling a burner, casting bullets for one of my muzzle-loaders in a skillet. This was before my knee surgery; my leg was all askew and I was in some serious pain. We were talkin' about kids—her little girl and mine—and I finally just cut to the chase and said, "I like you. You need to work here. Be here at eight in the morning."

She seemed confused. "I'm not really looking for a job," she said. And with a background in interior decorating, I could understand why she wouldn't be looking for a job at Red Jacket even if she were in need of employment.

"I didn't ask you that," I replied. "You just do whatever you've got to do and be here at eight in the morning."

She nodded her head, said "yes, sir," and that was it. Sure enough, she was at the shop at eight the next morning.

Now, for all intents and purposes, Rebecca is my right hand. On many days she's my left hand, too. Anything that doesn't have to do with welding or turning a wrench pretty much falls on Rebecca's shoulders. From setting up client meetings to dealing with the production company to dealing with the attorneys to handling the PR and marketing to keeping us on schedule to reminding me when to eat—I could go on for hours. Long story short, RJF would be in a world of hurt without that gal. Trust me. Just because you haven't seen her on television doesn't mean we could function without her.

DAVE WILLMAN

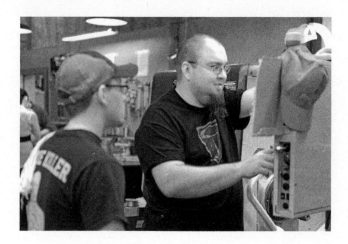

Dave came to us for all the right reasons: for as long as he could remember he liked things that went *bang*. Work-

ing in Michigan as a motorcycle mechanic, a friend and previous RJF employee told him we were on the hunt for good people. Not gun people, mind you, just good people. Workers. In a blink he took his vacation time, bounced down here for a working interview, and a few weeks later he ordered some "Red Jacket room service"—had his folks bring him his tools. The rest is history.

ERIC McGEHEE

If you looked at Eric's professional dossier, no way would you ever think he'd join the RJF team. He has a master's in music education and is classically trained as an opera singer. But the guy can wrench on guns of all types and calibers with the best of them, not to mention handle just about any task I throw his way. So after a meet and greet at my birthday bash, he became a member of the tribe. In addition to doing whatever needs to be done, Eric is now our official Christmas tree maker. And trust me on this one; you ain't never seen a Christmas tree like a Red Jacket Christmas tree!

ZACH HALL

In 2006, Zach, a machinist by trade, was building suppressors in Franklin, Tennessee—more of a hobby for shits and giggles and a little extra pocket change—and during his research of competing "can" designs on the market our paths crossed. It wasn't hard to see the boy had talent by the truckload so I made him an offer he couldn't refuse: "You'll work long hours, make very little money, and I'll probably be an asshole every now and then, but you'll be loved by everyone around you and you'll have a hell of a time." How could he resist?

SEAN WEBSTER

Sean and I first commiserated over a mutual love of muzzle-loaders. Like many other RJF employees, Sean wasn't looking for a job when we met but I hired him anyway. While Red Jacket is known for its AKs, Saiga-12s, suppressors, and other so-called tactical toys, it's black powder and muzzle-loaders that get my juices flowing. Sean and I are kindred spirits in that respect. Truth is he's a frontiersman at heart. Take away modern technology and he'd get along just fine. Couldn't imagine him partnering with anyone else. Together, he and I are RJF's muzzle-loading division.

Afterword

The world is filled with violence. Because criminals carry guns, we decent law-abiding citizens should also have guns. Otherwise they will win and the decent people will lose.

—JAMES EARL JONES

lthough Red Jacket's been around for a bit now, in the grand scheme of things we're really just getting started. Not a day goes by that we aren't conjuring up new ideas, working at establishing new business relationships, and trying to improve the overall level of service we provide to our customers. Trust me. It ain't easy. The business we're in, the current state of the economy, the folks who simply don't like what we do. Am I complaining? Hell no. If anything, I'm giving you an open invitation. Get to know us, either through the show or anyplace we happen to be. We don't need to think alike to

find common ground. Just as long as you love this country, respect the men and women who fight for our freedom, and show respect to your fellow man, we can coexist just fine. Beyond that, I just want to say thank you. Thank you for tuning in for the last four years. Thank you for inviting us into your lives the way we've invited you into ours. Hopefully that relationship will continue for many years to come. Besides, who knows what's going to happen next at Red Jacket? I sure as shit don't but I can't wait to find out.

Acknowledgments

Without the support and belief of my family, none of it would have been possible. Guys, I'm nothing without you.

RED JACKET FIREARMS

Stephanie Hayden Charlie Watson
Kris Ford Rebecca Ramsey
Joe Meaux

Ya'll are my heart and soul. Without you, there is no Red Jacket.

JUPITER ENTERTAINMENT

Stephen Land Steve Purcell
Patrick Leigh-Bell

DISCOVERY CHANNEL TEAM

Eileen O'Neill Joseph Schneier
Dolores Gavin

DISCOVERY COMMERCE TEAM

J. B. Perrette Mindy Barsky
Sean Atkins Sara Shaffer
Elizabeth Bakacs Cady Burnes
Sue Perez-Jackson Tracy Collins

HARPER/IT BOOKS

Mark Chait Kaitlyn Kennedy
Bethany Larson

FOLIO LITERARY MANAGEMENT

Scott Hoffman Erin Niumata

FOX LAW GROUP

Sandy Fox

And special thanks to Adam Rocke.

Photo Credits

Credit: Courtesy of the author
Pages x, xv, xvi, 26, 31, 35, 36, 45, 46, 67, 103, 141, 148, 192, 193, 196, 197, 200

Credit: ©2013 DCL
Pages 52, 55, 56, 65, 66, 69, 77, 80, 83, 84, 94, 95, 115, 120, 128, 142, 153, 157, 170, 174, 175, 188, 195, 199, 201

Credit: ©2013 DCL/Sandy McDougall
Pages 58, 62, 71, 109, 169

Credit: ©2013 DCL/Jeremy Cowart
Pages vi, 63, 127, 178, 190, 202, 204

Credit: ©2013 DCL/Jupiter Entertainment
Pages 72, 98

About the Author

WILL HAYDEN is the founder and owner of Red Jacket Firearms. A native of the Baton Rouge, Louisiana, area, he started tinkering with guns at an early age and moved on to building weapons himself. He opened his custom-firearms business in 1999 and his daughter, Stephanie, came on as a business manager and partner in the operation in 2003. The partnership has led to Red Jacket's continued success as "the nation's most unique weapons business." A former marine and a great patriot, Will is also an avid history buff, and he believes the true power of a weapon is about "holding a piece of history." When he's not in front of the *Sons of Guns* cameras, he likes to take his team on road trips and his daughter backcountry hiking and elk hunting.